MOONLIGHT

A24

Section I.

Section II.

Section III.

Section IV.

Prologue
by Frank Ocean **007**

Screenplay
by Barry Jenkins **010**

24 Frames **148**

Film Noir
by Hilton Als **200**

Acceptance Speeches **208**

In the southeast, in our youth I saw streetlights and taillights and lighters light spoons and guns alight but there was no moonlight. When my mother lit the stove pilot with a match, when we let Mr. Joseph The Wino live in our back shed I sat on the stairs and spoke to him. That little light that made it through the doorway from the kitchen lit his face as he told me stories about when he used to sleep with no cover from the moon. Talking to him I learned that the moon had no light of its own, that all its light came from the sun. Before I left the house to walk to the gas station I wrapped my head with a silky rag to set my waves. On the walk I imagined one day they would shine like the sea under moonlight. I knocked on your door on the way back and you answered it without a shirt, and turned your back on me and I shoved you for leaving me hanging but we were too familiar for greetings, we were too familiar for so many words and I slept over. On a late Saturday morning when the languor fell away we ran out into sunlight, it beamed on the targets on our brown backs. Midway through a game I wanted to see you from the sideline so I took a seat and followed the lines your body made under flood lights. In my car, the gauges and incandescent bulbs turned us different shades of blue. When we arrived we paid to stare off into silver screens and they wouldn't shine any light on our situation. And for so long it was like we didn't exist.

Frank Ocean

MOONLIGHT

Section I.

Moonlight
Written by Barry Jenkins

Based on

*In Moonlight
Black Boys Look Blue*
by Tarell McCraney

First, over BLACK, we hear... The SOUND of the ocean, then...

FADE IN:

EXT. 58TH TERRACE/13TH AVE - DAY

A bright Miami day. Or what we can see of it: our gaze fixed, looking into the front windshield of a wide, vintage car (think '60s, American).

At the wheel find JUAN (30s, some sort of Afro-Latino thing about him) pulling toward us and coming to a stop. Behind him, a shady, run-down apartment building abuts the road, three boys standing outside it.

Juan cuts his engine, exits the car and begins across the street. The boys tense up as Juan approaches, make room as he continues all the way over to the brick wall behind them.

 JUAN
 Business good?

One of the boys, TERRENCE (18, dreadlocks and rail-thin), bows his chest to speak.

 TERRENCE
 Business good. Everybody cleaned out, it's in the cut
 if you want it.

Juan just nodding his head, looking at the ground stretching before them, kind of day where phosphorous fumes wave above the asphalt.

 JUAN
 Hold on to that, register don't empty til' the weekend, feel me?

MOONLIGHT

Terrence nodding, the other boys' heads bowed slightly, a hierarchy here. As Terrence removes a chocolate Yoo-hoo from his back pocket...

...a zombie approaches.

Or rather, a customer, tall, lanky, haggard-looking man approaching across the road.

 TERRENCE
 (to himself)
 This muh—

The haggard man, continuing over, gets near enough to stand right over Juan. Juan looks up, simmering.

 JUAN
 Azu you okay, man?

AZU (30s, broken) staggers a bit, face unsure:

 AZU
 (Realizing)
 Oh my bad Juan. No disrespect.

 JUAN
 What you need?

 AZU
 You know you my man, right Juan?

 JUAN
 Azu don't bring that noise. I got *sells*, not samples.

Azu reluctantly extends some bills to Juan. Juan paying the money no mind, looks straight ahead as Terrence leans in, takes the money.

Beat.

 TERRENCE
 Nigga you know the drill.

Azu sighs, turns and begins down the block slowly, deliberately. Terrence watching him go, then...

...motions to one of the other boys, the boy watching Azu carefully then slipping away, around the corner of this complex, the third boy placing his back at the corner of the building.

As the other boy appears from around the corner again, hands stuffed in his pockets...

 LITTLE BOY 1 (O.S.)
 Get that nigga!

Juan looks away from Terrence, across the road and sees...

EXT. HOUSING PROJECTS - DAY - CONTINUOUS

Three young boys (adolescents, 12/13 years old) with sticks chasing LITTLE (similarly aged but smaller, a runt), who is running, terrified.

The three boys laughing as they give chase but... this is not a game, more like a hunt.

Little crosses the street in a panic, enters an unfenced lot, heads for the rearmost corner as the boys close in, chase him through —

EXT. CONDEMNED BUILDING/CRACKHOUSE - DAY - CONTINUOUS

AN UNHINGED FENCE — Little squeezing through, doesn't look back as the other boys attempt to shimmy and wiggle their way through, too big to glide through like Little.

LITTLE hauling ass, chest heaving as he rounds the corner on this condemned building. On instinct, the stairs taken two at a time, reaches the second-story landing and pushes his way into...

INT. CONDEMNED BUILDING/CRACKHOUSE - DAY - CONTINUOUS

Quickly: Little closes the heavy door behind him, engages the deadbolt.

Beat.

A beat of listening, the SOUND of footsteps hurrying up the steps, rushing to the door and...

POUNDING. Madness and pounding, the boys cackling like hyenas as they beat the living hell out of that door.

Little shrinking, backing away and covering his ears. The SOUND of things cracking under his feet as he moves: the ground is covered with glass and syringes, small plastic vials rolling around all over.

The pounding stops. Little staring at the door as he HEARS the boys descending the steps with that same juiced energy. Little's eyes never leaving that door — waiting, anticipating, expe—

BANG! A window, the rear bedroom. Doesn't shatter, just a loud, percussive thump. Little creeps across the room — the same CRUNCH of glass beneath his feet, creeps into...

THE REAR BEDROOM: more light in here than in the front, from that window. Little edges up to it, leans away to not be seen. Slowly, stealthily, he raises his eyes above the threshold, SEES the three little badasses who chased him. On cue —

THUMP! A ratty shoe clanging off the windowpane. Reflex — Little startles, throws himself against the adjacent wall.

As he clinches his eyes closed, breath cloistered up in his chest —

<div style="text-align: right;">UP CUT TO:</div>

A GLASS PIPE

...held up to catch the light.

INT. CONDEMNED BUILDING/CRACKHOUSE - DAY - LATER

Little stands in the kitchen of this place, holding the aforementioned glass pipe, staring at it closely.

He sets it down, starts opening cabinets and drawers, just a kid exploring, when...

BAM BAM BAM! — thudding from the living room. Rather than the door, a pounding on the front windows, on the boarded-up wood nailed shut where glass would be.

Little huddles in on himself, looks on terrified as...

...a light, a hand as the edge of the plywood gives, a full-side of it giving way to reveal a tall figure, calm. Adjusting for the light, we see him fully: it's Juan.

Juan reaching a leg over the threshold, stands just inside without encroaching on Little's space.

A beat as the two take each other in, then:

> JUAN
> What you doin' in here, lil' man?

Little says nothing, just watches him.

 JUAN
 You don't talk to strangers, huh?

Juan takes a step forward... and Little takes a step back.

 JUAN
 (raising his hands)
 Alright.
 It's cool.
 We cool.

Juan runs a hand across his scalp, thinking — What the hell does he do?

 JUAN
 Well listen: I'm a go get something to eat. You welcome to join me, I mean...

Juan begins across this small space, gets a hand on the deadbolt:

 JUAN
 Mind if I take the front door?

Juan opens the door, steps onto the porch, turns back. His stance open, one hand on the door, the other open, extended toward Little.

 JUAN
 Come on, now.
 Can't be much worse out here.

Off Little...

 CUT TO BLACK.

And over BLACK, the TITLE CARD:

LITTLE
I.

MOONLIGHT

INT. ROYAL CASTLE - DAY

Juan and Little at a booth, plates of food sitting between them.

 JUAN
 So...

Little just eating, not a single other care in the world but this meal.

 JUAN
 You not gon' tell me what yo' name is?

Nothing. Little finishing a drumstick, dips a biscuit into the gravy there. He's hungry.

 JUAN
 What about where you live? Gotta get you home,
 man. Can't just have you runnin' round these dope
 holes.

Juan reaching across the table now, slowly pulls Little's tray over to his side. Little just looking down at the empty table before him.

 JUAN
 My bad, lil' man. I wouldn't do you like that.
 I apologize, alright?

Juan sliding the food back to Little with his left hand, with his right reaches across to touch the boy's shoulder:

 JUAN
 I apologize, alright?

Little looking up now, holds Juan's gaze a moment. Nods his head in assent.

Off Juan...

CUT TO:

INT/EXT. JUAN'S CAR - DAY - MOVING

Juan at the wheel. And on the stereo, the same song bridged from the previous scene, something old-school but slowed (like Al Green's "Let's Stay Together") chopped and screwed.

Juan ad-libs with the music, crooning. Little gives him the weirdest.

JUAN
(teasing)
What? You don't know nothing 'bout that chopped and screwed?

Little shrinking into his seat, shy. Juan just shakes his head, mega-watt smile as they push on.

EXT. JUAN'S HOME - DAY

A plot of land, a modest bungalow set way back from the road, the longest grass driveway.

Juan shutting the driver's-side door of that Cadillac, beginning up the lawn toward the front door of this place, calls out:

JUAN
Teresa!

Juan continuing up the walk as a woman (TERESA, 20s, motherly) appears at the front door, steps onto the porch as Juan gestures back to...

INT/EXT. JUAN'S CAR - DAY - CONTINUOUS

Little still sitting in that passenger seat.

Looks out beyond that windshield, Teresa and Juan talking, gesturing animatedly back at the car.

Little shrinking down in the seat a bit, suddenly bashful as...

...<u>Teresa begins toward us</u>, toward him.

Little watching the whole way as she approaches, makes her way down to the driver's side of that Cadillac, a hand to the door there and...

...takes a seat.

A meeting of eyes between Little and Teresa, looking right into one another.

The longest beat, then...

INT. JUAN'S HOME - NIGHT

Juan, Teresa, Little gathered at a modest dining table, the two grown-ups watching the child going to work on what appears a delicious plate of home-cooking.

Something odd about this dining room: the walls are two colors, in the midst of being painted. A few paint tins and rollers line the floor, a work in progress.

 JUAN
 You don't talk much but you damn sure can eat.

Teresa smiling.

 TERESA
 That's alright, baby. You talk when you ready.

Little looking up from his plate at that, something about Teresa's voice, her presence, clicking with him.

> LITTLE
> My name Chiron.
> (and)
> But people call me Little.

> TERESA
> I'm gon' call you by your name.

Little shrugs.

> TERESA
> Where you live, Chiron?

> LITTLE
> Liberty City.

> TERESA
> You live with yo' mama?

A nod yes from Little.

> TERESA
> And what about yo' daddy?

Nothing. Not a blink, not a nod, barely a breath, just stillness.

> TERESA
> You want us to take you home, then?
> (and)
> After you finish eating, maybe?

Little lowering his eyes now, gaze going to the table in front of him:

> LITTLE
> No.

Teresa and Juan exchanging a look: a confirmation between them.

> TERESA
> Okay then.
> Okay.
> You... you can stay here tonight.
> Would you like that?

Little nodding yes.

Off Juan taking in this kid...

INT. JUAN'S HOME, SPARE BEDROOM - DAY

LITTLE: fast asleep, extremely close to him here, chest rising and falling with the soothing rhythms of sleep.

REVERSE ANGLE: JUAN. Standing above the boy, watching him sleep.

INT/EXT. JUAN'S CAR - DAY - MOVING

The windows down, a steady but muted wind, Little with his head leaned out the window there.

Juan watches the boy as he drives, taking his eyes away from the road to look across the bench seat every now and then.

EXT. PAULA'S APT - DAY

Juan and Little standing on the porch of this closed apartment, Juan's hand on Little's shoulder.

They're waiting, Juan looking through the curtains there, no telling

if anyone's inside or not. Is raising his hand to knock once more, when...

> VOICE (O.S.)
> *What happened!?*

Juan turning, sees a thin, exhausted (but attractive) woman hurrying over.

This is PAULA (mid 20s, Little's mother). From the looks of her uniform and a badge that reads "Paula Harris," a nurse, just off the night shift. She goes right to Little, pulls him into her arms, shields him from Juan:

> PAULA
> What happened Chiron? Why you didn't come home like you supposed to?!

Nothing from Little, eyes cast down, afraid, ashamed. Paula looking up to Juan, finally gets a good look at him:

> PAULA
> And who is you?

Juan considering this, is oddly unsure how to respond, so...

> JUAN
> Nobody.
> (and)
> Found him yesterday. Found him in that hole over on 15th.

And at Paula's face dropping with recognition:

> JUAN
> Yeah. *That* one.

Paula lowering to her knees, eye-level with Little again, inspecting him:

 JUAN
 Wouldn't tell me where he stayed until this morning.
 Some boys chased him into the cut. Seemed scared
 more than anything.

Little embraces Paula, buries his face in her chest. Paula holding on but looking past him, she and Juan holding eyes.

Paula rises, Little slipping behind her.

 PAULA
 Thanks for seeing to him. He usually can take care
 of hisself, he good that way, but...

Paula looking past her son, past this man, thoughts drifting off. From the looks of her, just a hardworking single mother in over her head.

Juan's gaze lingering over her, clearly seeing the same and yet... just a bit more.

INT. PAULA'S APT - DAY - LATER

Paula standing as Little sits on the couch — Paula standing above Little, hands on hips.

Doesn't speak, just looks at the boy, a bewildered look. Still in that uniform, strain at the corner of her eyes.

 PAULA
 You a real damn prize, Chiron, you know that?

Little just looking at his feet, staring at the floor.

 PAULA
 You got'sta come home when you meant to come
 home, you hear?

Nothing from the boy. Paula gets down to a knee, takes both his shoulders in her hands:

 PAULA
 You hear?

A slow nod from Little, does indeed.

A beat and, like a wave, something relaxing in Paula, makes her soft, loving again.

 PAULA
 That's alright baby, that's alright.

Paula rests a hand on Little's head, pulls him in tight.

 PAULA
 Mama just want to make sure you're okay, that's all baby.

Paula still holding on to Little, to say it's for dear life would not be at all an exaggeration.

She releases him and, on cue, Little plops himself down in front of the television, reaches for the analog dial, but —

 PAULA
 Nuh uh, your TV privileges is revoked, Buddy Roe.

Off Little…

EXT. GWEN CHERRY PARK - DAY - MOVING

At first, just dirt and rocks, patches of grass coming into view intermittently as we move over this landscape.

A beat, then…

MOONLIGHT

...the sound of heavy footfalls, twelve to fifteen boys (aged nine to fourteen and of various shapes and sizes, all black), thundering past.

WE GO INTO THIS MASS OF ENERGY

...a wild series of images, our view whipping to and fro as the boys converge and attack, every one of them focused on a single boy zigging and zagging among them.

That boy finally on the ground, a mass of bodies as all the other boys pile on top, a true gang-tackle.

The boys unpiling now, one by one rising from the scrum, unveil the grass-stained body of a fifteen-year-old boy smiling ear to ear.

The tackled kid rises, gets up holding what appears to be a wadded-up bunch of newspaper at his chest. All eyes on it as he balances it in his hands before tossing it...

IN THE AIR

...floating, hanging up there forever until it lands...

AT LITTLE'S FEET

Little looking down at this thing in disbelief.

All eyes on Little here, *voraciously* on Little, menace, harm, hunger all written there.

Little backing away slowly, one foot behind the other, but...

...someone kicking the ball, moving it along after him, stalking him.

They all circle Little, no room to back away farther, no escape.

A beat of eyes — expectant, punitive eyes — then...

A breath, a flash, a miracle: some *thing* reaching into the scrum, down low at Little's feet, snatches the wad away.

Pandemonium, all minds and bodies following that hand, that paper, the scrum muscling past Little, leaves him bumped but spared as the action moves away, elsewhere along this ruddy excuse for a field.

Little bringing a hand to his eyes, looking after all the movement down there: in the center of all those boys, another kid nearly his size but, in the determination on his face and bravura of his run, a bit... *tougher.*

Off Little watching the boy rip and run and evade kids twice his size...

EXT. GWEN CHERRY PARK - DAY

Little walking alone along this side street.

Kicking rocks, grabbing the branches of small trees, listless when he hears...

 VOICE (O.S.)
 Hey, Little!

From a ways off that came, Little looking back, into the sun. Can't quite make him out at first but squinting to see him better, a bit of familiarity: it's the kid who just saved his ass.

Little waiting as the kid hurries to catch up. He's a bit fucked up, shirt torn, a scratch along the bridge of his nose.

 KID
 Wassup man.

 LITTLE
 Hey Kevin.

KEVIN (a facsimile of Little but stronger, more broken in).

 KEVIN
 Why'd you leave?

 LITTLE
 I'on't know.

Kevin falls into step, the boys walking together now.

 KEVIN
 Yeah, it get borin' after a while, I guess.

The boys continue on, Little looking to his new friend every now and then, checking him.

 KEVIN
 (at Little's looks)
 What?

Kevin reaches for his own face now, hand to his chin:

 KEVIN
 Is it bleedin'?

Kevin turns his head just so, invites Little to inspect. Little reaches over, touches Kevin gently at the neck, just below his ear.

Little brings his hand back to himself without a word, just this walking, arms swinging, the sound of their feet along the pavement.

Small glances from one to the other. Kevin smiles:

 LITTLE
 What?

 KEVIN
 You funny, man.

 LITTLE
 Why you say that?

 KEVIN
 You just is, that's all.

Again this walking, lack of words, just their arms swinging, movement.

Up ahead, the school they've been walking beside all this time gives way to a field. They're headed right for it.

Kevin taps Little, gestures.

EXT. GWEN CHERRY PARK - DAY

Kevin and Little standing before one another in this clearing, face to face, like ancient samurai before a contest.

 KEVIN
 See, you just gotta show them niggas you ain't soft.

 LITTLE
 I *ain't* soft.

Always and forever a hothead, this one.

 KEVIN
 I know man, *I* know. But...
 (pauses for effect)
 ...don't mean nothin' if *they* don't know.

No response from Little, maybe he gets it, maybe he doesn't. No matter...

 KEVIN
 Come on...

Kevin grabs him, places one arm across Little's shoulder, the other around his waist, rests his head in Little's chest.

 KEVIN
 ...let's wrestle.

Little limply obliging, visually, physically passive.

 KEVIN
 Come on man, you want these niggas to pick on you every day?

That gets to Little, the boy locking on, muscles tensing: they're wrestling.

This is anthropology, anatomical vignettes, the struggle of these two boys isolated to the simple, incomplete movements of partially glimpsed bodies.

These are children. Sexuality is absent in these images and yet, the hints of something sensual, fleeting in its appearances; Kevin's cheek wedged close to Little's neck, blades of grass sticking to their skin.

The boys on the ground, turning and rolling and laughing, huffing through exhausted breaths. Slowly, their voices going mute, the only sound the movement of their bodies against each other, against the grass.

Physical exhaustion. The boys lie flat.

Beat.

Both Little and Kevin on their backs, looking skyward, chests

heaving from the exertion. Kevin pops tall to his feet, fixing his mottled shirt.

> KEVIN
> See Chiron, I knew you wasn't soft.

Kevin looking back at Little, looking down at him lying there, Little fully returning his gaze, in these twenty pages the first time he's looked at anyone thus.

EXT. JUAN'S HOME - DAY

A picnic-style table on Juan's front porch, two deck chairs haphazardly beside it.

Little is sitting atop the picnic table, small bookbag tossed to the side, shirt distressed and grass-stained from wrestling. A pencil in hand, he's doing homework.

A beat with Little, diligently at his work, times tables or some such thing, then...

...the SOUND of tires easing to a stop, Little's eyes rising, gazing out after the noise.

Sets his pencil down as the noise ceases — break pads squeaking, the sound of a car door opening.

Little lowering his eyes as footsteps approach. After a beat of those steps nearing...

REVERSE ANGLE: Juan standing here, keys turning over in his hand, head cocked to the side, a puzzled look.

Little slowly, but... *assuredly* raising his eyes to meet Juan's.

Beat.

Juan looking from Little to the road and back. The look on his face: *How'd he???*

EXT. MIAMI BEACH, SHORE - DAY

Juan and Little standing ashore, both of them pulling off their shoes, their shirts. This being Miami, both already dressed in shorts, this heat.

Juan moving away, heading toward the surf. Little following, hurrying to catch up, literally taking hold of Juan's shirt as they move...

INTO THE OCEAN

...away from shore, slow, awkward steps, feet in sand.

And Little so small, the water rising quickly.

Juan still moving away from shore, notices Little no longer beside him. Looks back, the boy a few meters behind.

Little looking to Juan and back to the shore behind him, gauging the distance between the two. The look on Juan's face: *Well?*

Little diving into the water before him, face down, arms flailing, fighting the water as much as he's moving *through* it.

Juan steadying himself, buttresses himself against the current as he reels Little in. The boy clings to him, gasping for air, spitting out salt water.

> JUAN
> Hey hey hey, I got you lil' man, I got you,
> *cálmate, cálmate.*

It's movie magic but they're a good ways out now, thirty, forty yards from shore.

The water's not so deep out here, Juan standing. Little is far out beyond his height however, Juan supporting him, holding him out at arm's length.

> JUAN
> You alright?

A nod from Little as he wipes salt water from his eyes.

> JUAN
> Good, good. Now... you gotta help yourself now, gotta move your legs, keep yourself up.

Juan watching as Little flails his legs beneath the surface. Juan laughs.

> JUAN
> Nah, not like a chicken, you gotta move 'em side to side like, like you making waves with your feet.

Juan going into a tread, very smooth, like someone raised in the water, born at its edge.

Little taking it to heart, does a passable job of treading.

> JUAN
> Not bad, not bad.
> (and)
> Bet you ain't know you could float, huh?

Juan taking a hand and placing it under Little's legs, gently gesturing him onto his back:

> JUAN
> Trust me, I got you.

MOONLIGHT

Little laid flat atop the surface now, bobbing with the waves.

 JUAN
 Now just relax, alright, *relax*.

Little complying — Little *floating*, the look on his face pure joy. For once, a kid.

 JUAN
 See?

Juan slowly, gently, easing his grasp, letting Little go:

 JUAN
 Relax now, stay relaxed. See?

Juan circling as Little continues to bob with the surface, swimming around Little for this last part, circling him.

 JUAN
 You ready to learn how to swim?

 LITTLE
 Yeah.

Juan standing again, gets his arms under Little and turns the boy face down in a swimming position.

 JUAN
 Alright, you saw me swimming, right?

Nod from Little.

 JUAN
 Okay, do like I did, don't put your head under water.
 And your arms, try and do 'em like I did mine.

Little mimicking Juan's swimming as Juan holds him aloft, Juan holding him fully in place for this practice.

 JUAN
 Smoother, more easy-like.

Little settling noticeably, gradually. It's a stretch but... looks passable, like maybe he *could.*

Juan turning him back upright, Little going back to his awkward treading.

 JUAN
 Alright lil' man. I think you ready.

Little considering that, bobbing in the ocean as he treads. His eyes on the water stretching out before him, endless. Even in this dying light, stretching on forever.

Meets Juan's gaze now. Finds compassion, hope there.

Off Juan...

EXT. MIAMI BEACH, SHORE - DAY

Little and Juan sitting ashore, a towel wrapped around the boy as they watch the moon come up.

The moon making its first appearance on the horizon — SOUND of the waves running back and forth, to and from shore.

 LITTLE
 Juan, can I ask you somethin'?

 JUAN
 Yeah lil' man, ask me whatever.

Little nodding, taking his time, oddly nervous about this:

> LITTLE
> Okay... why your name Juan?

> JUAN
> How you mean?

> LITTLE
> Juan is like a Spanish name.
> (and after a thought)
> But you black just like me.

Juan turning his head to the boy. A smile and then a full blown laugh, Juan losing it.

> JUAN
> (through his laugh)
> Little, you a funny lil' dude, you know that?!

Juan slapping his knee here, really enjoying this moment.

> JUAN
> (coming down)
> Let me tell you somethin': it's black people *everywhere*, you remember that, okay? Ain't no place in the world ain't got no black people, we was the first ones on this planet.

Little embarrassed, poking at the sand before him. Juan places a hand to his shoulder:

> JUAN
> I'm from Cuba. Lotta black folks in Cuba but you wouldn't know it from being here. Was a wild lil' shorty just like you, used to run around with no shoes on when the moon was out.

Juan's thoughts drifting, taking him away from here for a beat. To those waves possibly, arriving on this shore from that other shore he's describing not so far away.

> JUAN
> This one time... I ran by this old, old lady, was just a runnin' and a hollerin' and cuttin' a fool, boy. And this old lady, she stop me and she say to me, *"Look at you. I was a lil' bad ass too, you know."* She say, *"Look at you"* and I say *"Look at you!"* Then she smiled and she say, *"Running around catching up all this light. In moonlight,"* she say, *"black boys look blue. You blue,"* she say. *"That's what I'm gone call you: Blue."*

Off Little.

EXT. PAULA'S APT - NIGHT

Little and Juan approach the apartment complex.

> JUAN
> So how you like swimmin'?

Nothing from Little. Heard him but the words too heavy to present themselves.

> JUAN
> That good, huh?

Juan grabs Little's head and playfully shakes it. The boy smiles, bashful, happy.

They reach Paula's apartment, Little knocking and calling out:

> LITTLE
> *Mama!*

A beat, then... Paula's at the door, a bit drowsy, disheveled in a way different from the work-weary version glimpsed before.

A moment of Juan taking in Paula. None of them utter a word for a moment, just the distinct sound of a can opening from inside the apartment, all of them noting it.

 LITTLE
 Hey Mama.

 JUAN
 I—

Paula takes Little by the shoulder, pulls him inside.

INT. PAULA'S APT - NIGHT

Little standing away from Paula, face open and curious as we see what he sees: an average, working-class black man — longshoreman type — sitting at the small dining table just off the kitchen.

Paula standing as this man sits watching Little, neither of them seeming very familiar with the other; neither seeming very *interested* in the other.

A lot of busy work from Paula there, taking things into her arms: glass things, aluminum things, curious things we cannot *quite* see.

 PAULA
 (at man)
 Come on.

Paula heading off toward the rear bedroom, the man quietly rising after her, the can of Olde English we heard opening clutched in his hand as he follows her across the apartment.

Little watching the procession — confused, suspicious — eyes lingering on the bedroom door as it closes behind them.

INT/EXT. ELEMENTARY SCHOOL - DAY

Little entering the front gates of this school.

No other kids around, he's either late or early as a SCHOOL GUARD waves him through.

INT. ELEMENTARY SCHOOL, DANCE ROOM - DAY

An open room: high ceilings, grey dance mat spanning the bulk of the room, mirrors running the length of two walls, a ballet studio.

Fifteen to twenty boys and girls moving about — no coordination, just movement and silliness.

We find Little among them, throwing his head back, moving his hips to lord knows what rhythm. And holy hell: for the first time all film, it looks like he might be having fun as we...

CUT TO:

INT/EXT. ELEMENTARY SCHOOL - DAY - MOVING

Moving with Little as he makes his way along an exterior pathway within this school.

His backpack pulled tight on his shoulders, no one else around as he crosses this space. Ahead of him, a wooden plank appears, leading to adjoining portable classrooms.

Little heads up the path, steps into...

INT. ELEMENTARY SCHOOL, PORTABLE CLASSROOM - DAY

Little taking two steps in, stops immediately.

REVERSE ANGLE: A circle of boys

...seven in a semi-circle, their backs to us, older-looking for an elementary, all of them looking down and *in* on one another.

All eyes go to Little, a hurried, hushed business. One of the boys breaks away from the circle, hustles over. As he nears, his identity becomes clear: this is Kevin from our earlier "wrestle."

> KEVIN
> Somebody with you?

A nod "no" from Little, Kevin moving past him, over to the portable door and "locks" it. Grabs Little's shoulder strap, pulls him over to the circle.

> KEVIN
> I swear it was locked.

...wedges Little...

INSIDE THE CIRCLE

...the other boys barely paying attention as we take them all in, drifting from face to face inside this circle.

All their eyes and hands are cast down: <u>they're comparing their dicks.</u>

We drift within this circle:

> PORTABLE BOY 1
> Yo' shit ugly as hell.

> PORTABLE BOY 2
> So, at least mine ain't a peanut.

> PORTABLE BOY 3
> He got a Freddy Kruger dick, yo' shit look like Freddy.

> PORTABLE BOY 1
> Yo' shit ain't even that big, it's like the same size as mine, look.

Boy 1 leaning into the circle, his head nearly butting Boy 2's, facing him, they may as well be touching dicks.

> PORTABLE BOY 1
> See!

Boy 1 distracted now, looking over at Little.

> PORTABLE BOY 1
> Who let his ass in?

> KEVIN (O.S.)
> He just came in.

Kevin is over at the door again, playing lookout.

> PORTABLE BOY 1
> What they call you? *Little*, right?

> PORTABLE BOY 1
> Show your shit.

> PORTABLE BOY 3
> Why you think they call him Little?

Laughs from all the tough guys gathered, Boy 1 grabbing Little roughly by the neck, watching as Little reaches down to himself, nervously unzips his pants.

Beat.

All the eyes here cast down again, staring down at Little, down at his dick.

A curious, prolonged silence, then...

KEVIN

...looking back over his shoulder, back at the circle.

From his vantage, the backs of all those heads cast down and focused on Little.

Off Kevin's gaze, CUT TO...

INT. PAULA'S APT - DAY (DUSK)

Little entering, stopping himself just a few feet inside as the door closes behind him.

A beat of Little listening to the house, tiny ears perked just so. Glances at the far wall — a modest television used to be there. Blinks in confusion.

Off the sound of silence...

CUT TO:

FLAME

...a chemical flame of blue and red.

INT. PAULA'S APARTMENT, KITCHEN - NIGHT

The front burner on this gas range, Little's scrawny, lanky arms setting a five-gallon pot of water to the stove.

The quickest beat of Little before the stove, then...

INT. PAULA'S APARTMENT, BATHROOM - NIGHT

Looking down into a quarter-full bathtub, fresh water pouring into it from the spigot.

The run of water stopping, the rippling surface slowing as footsteps tread away. A quick beat, then... the return of footsteps, the sound of them growing nearer as....

REVERSE ANGLE:

Little here carrying that five-gallon pot, from the steam coming off it, searing hot with boiling water.

Gets it right up to the edge of the tub, expertly, *carefully* pours it in, face leaned back to avoid the steam furiously rising from the surface.

Finishes this pouring and sets the pot down behind him, on its side so the handle props most of its metal surface from the carpet. Reaches down to the floor, retrieves a bottle of dollar-store dish-washing liquid.

As he squeezes a ton of this stuff into the water...

CUT TO:

LITTLE

MOONLIGHT

...in that tub now, soaking in bubbles.

A beat of the boy at peace.

An *extended* beat of this boy at peace, right here with him for a change, no distractions, no deflections.

So young and yet... so much happening behind those eyes. So much *weight*.

INT/EXT. JUAN'S CAR - NIGHT - MOVING

Neck craned out the window, cruising the neighborhood.

> VOICE (O.S.)
> *Heyyyyy, Juan!*

Juan barely nodding at whomever that came from, continuing on his way as we CUT TO:

TERRENCE

...counting out dollars.

EXT. ABANDONED COMPLEX - NIGHT

Terrence completing a transaction, stuffing money into his pockets and nodding in the direction of one of his runners.

Standing opposite him, a face we've seen briefly but will recognize: Paula's longshoreman.

As the longshoreman moves off, approaches the runner appearing from behind the complex, Juan approaches, that smooth easy gait of his.

It's a brief moment, but... Juan and the longshoreman meet eyes as they pass one another, nothing of import, but... a moment.

JUAN

...approaching Terrence with a nod, all that needs to be spoken as Terrence nods back, whistles at one of the other boys, sends him running off into the cut.

> TERRENCE
> Been a good one today.

Just a nod from Juan, his attention elsewhere now, following after the longshoreman. Down the block a ways, not close but within shouting distance, we SEE the longshoreman getting into the driver's side of a Chrysler sedan.

Beat.

> JUAN
> They basin'?

Nothing from Terrence, just watching the same as Juan.

> JUAN
> You lettin' niggas light up at the spot, now?
> (moving now)
> You know the rules, no lightin' up at the spot.

Juan getting to the sidewalk now, moving toward the longshoreman's car a block or so up ahead.

Gets there, finds the windows rolled up, a flash of flame emanating from inside. Knocks on the window.

Longshoreman rolls it down with a drugged-out smile, shrugging his shoulders in apology. Juan not amused by the display and,

catching a glimpse of the woman in the passenger seat, clicks into something much more menacing: it's Paula.

> JUAN
> What the fuck?

Juan rounding the car, wastes no time getting to the passenger-side door, pulls it ajar:

> JUAN
> Get out.

> PAULA
> Who you—

> JUAN
> Get the fuck *out*.

Juan *helping* her out, takes her by the arm and pulls her to her feet, out here in the road with Juan under street light.

Terrence and the others hurrying over at the commotion, Juan looking to the longshoreman (he's lighting a cigarette, couldn't care less), waves the boys off.

Beat. A very long beat, Juan and Paula both in shock, standing in the road with no clue what comes next. The longshoreman steps from the car, cigarette to his lips, sits on the hood and leans his back to the windshield, puffs into the night.

Paula clinching in on herself, closes her eyes, almost childlike to make it go away.

And then, suddenly... coming alive, moving toward Juan, every step something clicking, something changing.

Gets right up in his face.

 PAULA
 Who the hell you think you is?

Juan shook, never expected her to jump in:

 PAULA (CONT'D)
 Who the *fuck* you think you—

 JUAN
 Bitch.

Juan grabbing Paula, pushing her back against the car, his hand at her throat driving her back as he subdues her.

Drives her against the hood, releases her forcefully. Paula's eyes alight with rage, chest rising as she watches Juan staring at her from across the road.

 PAULA
 So... you gon' raise my son now?

Nothing from Juan, all stillness in his holding this gaze:

 PAULA
 Huh?

Juan lowering his eyes, legitimately weighs the question.

 PAULA
 You gon' raise my son?

Paula sucking her teeth:

 PAULA
 Yeah... that's what I thought.

JUAN
(snapping)
You gon' raise him?

PAULA
You gon' keep sellin' me rocks?

Paula turns from Juan, reaches into the Chrysler, pulls her pipe, a lighter from there. Holds his gaze while taking a charred, black pull.

Exhales.

PAULA
Motherfucker.
 (and now)
And don't give me that "You gotta get it from somewhere" shit, nigga, I'm gettin' it from *you*.
 (beat)
But you gon' raise my son, right?

Paula exhaling into the night air again, lets her head loll a bit to funnel the smoke.

Places the pipe back into the car now, approaches Juan, slow and confident:

PAULA
You ever see the way he walk, Juan?

JUAN
Watch your damn mouth.

Paula real close now, extremely close, her nose at his chin, looking up into his eyes:

PAULA
You gon' tell him why the other boys kick his ass all the time? Huh?

No backing down in Paula's eyes, the line drawn, so sure in this declaration.

And Juan? All doubt, prospect of follow-through finally before him, having to be reconciled.

Paula backing away from him, eyes never leaving his:

><div style="text-align:center">PAULA
(over her shoulder)
Come on, let's go.</div>

The longshoreman flicking his cigarette to the ground, the two of them slipping back into the Chrysler, ignition catching.

Off Juan, CUT TO…

INT. PAULA'S APT - NIGHT

Paula and Little facing one another, Little standing at his mother's feet.

We've caught them in the middle of something, just *after* something.

No words spoken, but Little's face: he's lost.

INT. JUAN'S HOME, DINING ROOM - DAWN

Perhaps a bit later than "dawn" but it's early. Juan moving about in a long-johns top and sweats, rubbing sleep from his eyes.

The moment would seem pure and sweet were it not for the revolver, the tightly rolled wad of bills strewn across the table.

Teresa is at the table with a notepad and pen. Teresa is *counting*.

Juan moves to the table but doesn't sit. Teresa takes up a cup of coffee, gives him a look, goes back to her ledger.

A beat of them in silence this way, Teresa counting, Juan thinking, then...

Juan crosses to the near wall, looks down to a roller there, a semi-dried pan of paint. He takes up the roller, adds a streak of white paint.

Looks off a moment, thoughts gathered. Adds another streak of white, then...

...a POUNDING at the door, a startle to them both and, as the POUNDING resumes, alarming.

Juan sliding the wad of money toward Teresa, takes up his pistol and heads for...

THE FRONT DOOR

...Juan just to the side of the door, pistol dangled in his hand.

> JUAN
> Who dat?

A beat, then...

> LITTLE (O.S.)
> It's me.

Juan looking down in confusion, doesn't immediately open the door, but... of course opens the door, pistol tucked behind his back to conceal.

Gets a good look at Little.

 JUAN
 (freaked out)
 Lil' Man.

Nothing from Little, holds his ground there on the porch, but... something in his eyes.

Something smoldering.

INT. JUAN'S HOME, DINING ROOM - DAY - LATER

Juan and Little sitting at the table. Again silence from the kid, everything cloistered up inside him.

 JUAN
 Alright, first things first, can't sit at the table like that.

Juan rising, takes Little's chair and slides it around the table a bit, stops the boy with a playful jolt:

 JUAN
 Don't ever sit with your back to the door, can't see who creepin' up on you.

Little still not amused, a completely straight face:

 JUAN
 I saw your mama last night.

 LITTLE
 (sotto)
 I hate her.

 JUAN
 I bet you do.
 (and)
 Hated mine too.

Little looking to Juan now, finally a break:

 JUAN
 Miss her like hell now. All I'm gon' say about that.

Teresa stepping in, sets down some kind of juice before them, a glass for Juan, a glass for Little. Juan about to take a sip of his when...

 LITTLE
 What's a faggot?

Juan...blindsided by that one, unprepared and unequipped to answer that.

Takes a sip of his juice, a deep breath and...

 JUAN
 A faggot is... a word used to make gay people feel bad.

Little nodding, processing that.

 LITTLE
 Am I a faggot?

 JUAN
 No. You're not a faggot.
 (and)
 You can be *gay*, but... you don't have to let nobody call you a faggot.
 (and after a beat)
 Not unless...

Juan looking to Teresa; Teresa motioning him to quit while he's ahead.

He takes another sip of that juice.

> LITTLE
> How do I know?

Again a look to Teresa, a shrug of the shoulders from her:

> JUAN
> You... you just do.
> (and)
> I think.

Little with both hands around his juice, all his senses focused there as his mind goes somewhere altogether different, clearly thinking deeply, forthrightly about this.

Juan reaching his cup back to Teresa:

> JUAN
> (sotto)
> Gin.
> (and to Little)
> You don't have to know right now, you feel me?
> (and)
> Not yet.

Little nodding, from his demeanor comforted by this. In this state, so wounded and curious, invites the empathy.

Little's eyes shifting gears. For a considerable beat, is completely to himself, mulling something over.

Lifts his eyes. From the mouths of babes:

 LITTLE
 Do you sell drugs?

Juan's face? *Crushed.*

He nods yes.

 LITTLE
 And my momma, she do drugs, right?

Again, something falling in Juan, hangs his head even lower.
A nod yes.

Teresa comes over, places a hand on Juan's back.

Little takes a sip of his juice, rises without a word. Exits the dining room.

The sound of his feet on tile flooring, front door opening, closing. Juan not moving, for once undone.

Beat.

Off Juan...

 CUT TO BLACK.

OVER BLACK, the sound of breathing, not labored or rushed but... proximal, right beside us, then...

 FADE IN:

...on a teenaged black boy staring across a classroom, gaze fixed with longing.

REVERSE ANGLE: Another boy's mouth, lips full, parted slightly in the act of "breathing" heard at scene's opening.

As the sound of that breathing escalates...

INT. HIGH SCHOOL, CLASSROOM - DAY

CHIRON (16) continues his staring. From just the look of him, this is clearly the Little character from moments before aged to his teens.

MR. PIERCE (the biology teacher, late 20s, black) clears his throat.

> MR. PIERCE
> Uh, Chiron, you need something?

TERRELL, a 16 year-old bully, interrupts.

> TERRELL
> That nigga forgot to change his tampon.

Laughter from the class, pack mentality.

> TERRELL
> He having women problems today. Ain't that right, *Little?*

More laughter.

> MR. PIERCE
> Alright, Terrell, that's enough.

> TERRELL
> Nah, can't be enough for Little... How much you *need*, Little?

> CHIRON
> Don't call me...

MOONLIGHT

 MR. PIERCE
 Alright, Terrell, that's *it*.

Terrell springs out of his desk into Chiron's face.

 TERRELL
 What the fuck you gone do, nigga? I'll fuck you up.

 MR. PIERCE
 Terrell, out! Right now.

Terrell blows a kiss to Chiron walking out.

 TERRELL
 School almost out Little...

Chiron looking after Terrell, staring at that closed door long after it's shut.

INT. HIGH SCHOOL - DAY

The bell's just rung, students funneling through a cavernous hallway, approaching a set of double doors spilling onto the school driveway.

In the middle of it all FIND Chiron, engulfed in this sea of chaos and, honestly, relieved to be so.

As Chiron scans the mass of students approaching those doors beside him...

...a considerable bump at his shoulder, Chiron looking up to find Terrell knocking past him. Terrell, Pizzo and a crew of roughnecks laugh and ad-lib shit-talk as they continue past, move through the crowd.

 TERRELL
 Umma be waitin' for yo' ass *Little*.

Terrell smiling as he hurries on, as if inviting him to a playdate.

Off Chiron's shook face...

 UP CUT TO:

INT. HIGH SCHOOL - DAY - LATER

Upstairs now, the second story of this building.

An open-air stairwell cornered on two sides by corrugated fencing, Chiron gets on his toes, looks down into the courtyard below —

Terrell is down there, rough-housing and talking shit with a group of knuckleheads.

Chiron speaking to himself...

 CHIRON
 (sotto voce)
 Come on Chiron.

...when he hears voices echoing behind.

Chiron looks, sees an admin-looking type moving away down the hall as a smooth-as-hell-looking teen approaches. As the teen gets closer, his identity becomes clearer: it's KEVIN.

 KEVIN
 Chiron, what you doing man?

 CHIRON
 Huh?

KEVIN

You just standing there straight *spaced.* School *been* out, nigga, you ain't goin' home?

CHIRON

What you still doing here?

KEVIN
(sucking his teeth)

Detention. Aimes caught me with this trick in the stairway.

CHIRON

What?

KEVIN

Yup.

CHIRON

With who?

KEVIN

Damn, you nosy, Chiron.

CHIRON

Oh sorry, my bad.

KEVIN
(Smiling)

All I wanted was some quick head you know, but this chick all like "Hit that shit, Kevin. Hit it with that big dick." Why she had to compliment a nigga? So I was like aight... we can *do* this. I started banging her back out she started making all this fucking noise though. Mr. Aimes walked in and went all Five-O...

 KEVIN (CONT'D)
 almost had my ass suspended, but I told him we was
 childhood sweethearts and all that, talked it all out.
 So I just got detention.
 (and)
 Eh, but that shit stay between us, yeah? I know you
 can keep a secret.

A slow nod from Chiron.

 KEVIN
 But real talk, I gotta go before this fool change his
 mind.

 CHIRON
 Alright, Kevin.

 KEVIN
 Later, Black.

Off Chiron...

 CUT TO BLACK.

And over BLACK, the TITLE CARD:

CHIRON II.

EXT. LIBERTY SQUARE HOUSING PROJECTS - DAY

Chiron approaching an apartment complex (different from Little's home in the previous story) in the twelfth stage of neglect, all chipped paint and autos up on cinderblocks out front.

Books and backpack in tow, he climbs a flight of stairs to the second story and approaches an apartment down on the far end. As he unlocks the door...

...a rush of energy greets him from within.

> VOICE (O.S.)
> (moving)
> Uh uh. No you cannot be here tonight. I got company coming.

INT. PAULA'S LIBERTY SQUARE APT - DAY - CONTINUOUS

PAULA (30s now, worse for the wear), looking as strung-out as ever as she rushes past him...

> CHIRON
> Hey Ma...

> PAULA
> (calling back)
> Find somewhere for you to be.

Paula slips into the rear bedroom, closes the door behind her with a considerable thud.

Chiron stares at that door indifferently: this is nothing new for him.

EXT. JUAN'S HOME - DAY

Chiron walking up the block, approaching Juan's home.

As he nears it, we HEAR:

> TERESA
> Well I'll be — *Chiron?!*

TERESA appears from the yard, out there in the yard, a bushel of dead palm fronds in hand. She's aged some, but certainly aged better than the rest.

Pulls Chiron into a hug, beaming the most amazing smile.

INT. JUAN'S HOME - NIGHT

Chiron and Teresa at the table in Teresa's dining room, fresh plates of food before both.

Teresa watching as Chiron picks at his plate, paying it just enough attention to qualify as eating. Still...

> TERESA
> What's wrong?

> CHIRON
> Nothing, I'm good.

> TERESA
> Nah. I seen good and you ain't it: what's wrong, Little?

> CHIRON
> Don't call me that.

> TERESA
>
> Don't call you what? Your *name?* You *grown* now?

> CHIRON
>
> I didn't say that.

> TERESA
>
> Then what you sayin'?

Chiron goes quiet. Doesn't take much.

> TERESA
>
> I'm just messin' with you boy.
> (and)
> And you right, that ain't no name for you no more. That ain't you. But if you wanna be somethin' different, you gotta earn it, you gotta make your name true, understand?

Chiron bows his head, out of embarrassment, out of shame?

> TERESA
>
> Hey, don't put your head down in my house, you know Teresa's rule: all love, all pride in this house, you feel me?

He mumbles, he nods.

> TERESA
>
> What's that?

> CHIRON
>
> Yeah.
> (and)
> I feel you.

Teresa rises. She's not a *tall* woman, so...

 TERESA
 Good.
 (she smiles)
 Now since you here, there's some stuff way back
 on the top shelf in the kitchen I've been meaning
 to get to.

Off Chiron's smiling face...

INT. JUAN'S HOME, SPARE BEDROOM - NIGHT

A simple room, small twin bed and a single sitting chair. A window just beyond the bed, looking out onto the side-yard.

Chiron standing over the bed, pulling the corner on a fitted sheet. From the looks of this room, no one sleeps here. From the looks of Chiron, he's made and unmade this bed before.

 CHIRON
 Thank you for this.

Hadn't noticed Teresa there in the doorway, looking on as Chiron goes about this work.

 TERESA
 You know you can stay here anytime, right?

 CHIRON
 Yeah. I know. Thank you Teresa, I mean it.

Teresa moving from that doorway now, approaching Chiron and that bed.

 TERESA
 But if you gonna stay here you got to learn how to
 make a bed, boy.

Teresa laughing as she takes that corner of sheet from Chiron's grasp, tugs it lightly: the entire cover slips off with ease.

 CHIRON
 What?

 TERESA
 How you mean, *what*? That ain't how you make no bed.

Teresa moving instinctively, has already got the two bottom corners snagged expertly, is pulling the third corner just so as Chiron watches.

 TERESA
 (playful)
 Think you slick, huh? Do it wrong so Teresa show up and do it right, huh?
 (laughs)
 You and Juan, thick as thieves, lemme tell you.

Teresa looking to Chiron for that last part, what begins as a smile slowly fading, shifting to something more reflective, heavy.

 TERESA
 You miss him?

Chiron holding her gaze, his silence answer enough.

 TERESA
 Yeah.
 Me too.

Beat.

 TERESA
 Me too.

Teresa turning from this room, moves down the hall, the door left ajar behind her.

Chiron staring after her — puzzling — just watching the empty space of the threshold there.

Off Chiron's gaze, CUT TO:

INT. JUAN'S HOME, BEDROOM - NIGHT - LATER

Chiron passed out, deep in sleep.

A beat of this slumber, then... the SOUND of water. Sound of water falling and echoing all over, then...

INT. JUAN'S HOME - NIGHT

Though less a cut than an exhale, a smooth transition as we drift through this home.

It's later; much later. And the SOUND of that water is insistent, hitting the roof like automatic fire. As we float past a retreating hallway, find...

CHIRON

...moving through this home in the same direction, his back to us — *leading* us.

As he walks through this space, another sound encroaches upon the SOUND of rain, with every step becoming clearer: the SOUND of a girl moaning, softly whispering inaudible words that coo and plea.

Chiron slows but continues, walks deeper into the home. He's approaching the kitchen. The SOUND intensifies as he finds...

KEVIN

...pressed hard against the back of a girl, SAMANTHA — older than both boys, sexy like a music video model.

Samantha leaned over the kitchen counter, skirt hiked up, back arched just so and pressing Kevin close from behind.

Kevin slamming into her again and again, these two fucking in a borderline ridiculous fashion.

Chiron still approaching, just inches away, can see Samantha's eyes, unspeakable bliss.

Kevin notices him finally, looks to him panting that killer smile of his:

 KEVIN
 You good, Black?

Chiron returning a blank stare.

Above them, the rain pours like the Victoria Falls as —

 MATCH CUT TO:

INT. JUAN'S HOME, SPARE BEDROOM - DAY

Chiron waking from sleep — in the same position as he'd been sleeping previously — face someplace between dreariness and confusion, searching for thoughts.

Looks out the window there. There's a small clock beside the bed; checks it.

EXT. LIBERTY SQUARE HOUSING PROJECTS - DAY - MOVING

Following Chiron down the street as he moves along in yesterday's clothes.

He walks quickly. As he reaches the corner.

> VOICE (O.S.)
> Chiron...
> Chi...*hey!*

Chiron turning, spots Paula hurrying over, breathing heavy:

> PAULA
> Hey baby where'd you go last night?

> CHIRON
> What?
> Why?

> PAULA
> I'm yo' mama, ain't I?

Chiron just holding her eyes, not worth a reply.

> PAULA
> Why you ain't just come home later, boy?

Paula smiles, the kind of smile that's been forgiven many times and many places over.

> PAULA
> You had me worried about you. But you getting grown, I guess I can't be keeping up with you all the time. Anyway, how Teresa doing? I ain't seen her since the funeral.

> CHIRON
>
> She fine.

> PAULA
>
> That's good baby. Listen, Mama locked herself out the door, can you... come let me in?

Chiron watching her, confused.

EXT. PAULA'S LIBERTY SQUARE APT - DAY

Paula and Chiron ascending the steps toward the second story, Paula moving ahead of him.

She gets to the door first, but... moves just past it to let Chiron do the honors. Smiles at him, something disguised in the gesture.

Chiron digging for his keys as Paula watches intently, at first in his pockets and now in his backpack, Paula's arms folded in a show of impatience.

After a moment of nodding nervously, scratching at her neck... Paula pushes past him, takes the door handle and lets herself in.

> CHIRON
>
> I thought you said...

INT. PAULA'S LIBERTY SQUARE APT - DAY - CONTINUOUS

Paula walking the apartment determinedly, looking behind half-closed doors and even opening a closet or two.

Easing now, she settles in the middle of the space, hands rested at the top of her head. After a beat of thinking, of coming to...

...she turns to Chiron, still there watching from the threshold of the apartment.

Paula smiles. Chiron approaches her:

>CHIRON
>Mama what you into?

>PAULA
>I need some money.

>CHIRON
>For what?

>PAULA
>That's my business, don't you ask me no shit like that.

>CHIRON
>I don't have no—

>PAULA
>Don't lie to me. I'm your mama. That bitch over there ain't no kin to you, *I'm your blood,* remember?
> (and)
>Now I ain't feeling good. I need something to help me out, baby, just float me across this shake, you hear?

>CHIRON
>Where I'm supposed to get money from?

>PAULA
>Teresa ain't give you nothing, huh? Your lil' play-play mama ain't put something in your hand? Now give me that damn money, Chiron.

Chiron reaches into his pocket, grabs a few bills there, can't be more than forty dollars but it's literally his last.

> PAULA
> Uh huh, I know that bitch like a hooker know her trick. You *my* child, okay? And tell that bitch she better not forget it.

> PAULA
> Go on to school. Ain't you late?

Chiron just staring, his mother in physical form but someone entirely different in mind and spirit.

Paula looks up from her counting, finds that scornful face so much like hers looking down on her.

INT. HIGH SCHOOL, CLASSROOM - DAY

Mr. Pierce at the head of a bored-looking class, explaining the differences between red and white blood cells.

Turns to the class:

> MR. PIERCE
> So can you see how a lack of white blood cells could be dangerous to the human body?

Crickets in here, no one taking that bait:

> MR. PIERCE
> *Okay*, can anybody explain what will happen to the body when there's not enough white blood cells?
> (and)
> Nobody's leaving this classroom until I get a response, this is more important for you than it is for me, trust me.

Pierce scanning the room here now, most honestly don't know the answer, others simply don't care.

Shockingly, a familiar hand goes up:

>MR. PIERCE
>Terrell?

>TERRELL
>Ummm yeah Mr. Pierce, I'm gonna answer this question, man but first I just gotta say, why the hell this nigga Little wearing the same shit he had on yesterday?

Big laughs from the class, Terrell hamming it up:

>TERRELL
>Ain't enough white blood cells in the world to check the funk comin' off his ass, this nigga foul Mr. Pierce.

>MR. PIERCE
>*Terrell.*

>TERRELL
>I'm sorry man, I'm sorry, no disrespect Mr. Pierce, I'm just sayin'.

Chiron gripping both edges of his desk, eyes locked there.

>TERRELL
>And check it: without the white blood cells, body can't defend itself. That's why all them gay niggas croakin' off that AIDS shit, ain't that right Little?

Off Chiron, still staring at that desk.

EXT. LIBERTY SQUARE HOUSING PROJECT - DAY - MOVING

Moving with Chiron as he makes his way down this street, alone against all this concrete, almost Western-like with his heavy backpack and sagging shoulders.

As Chiron continues, notice...

TERRELL

...following behind with a knucklehead friend (PIZZO, 16). The smiles on their faces are of pure delight: they're about to fuck with him.

Chiron speeds up.

>TERRELL
>Hey Little, wait up man, where you going to so fast?

Nothing from Chiron, just a quickening of his steps:

>TERRELL
>Nigga you can't hear?

>CHIRON
>(over his shoulder)
>Home.

>TERRELL
>(closing in)
>Huh?

>CHIRON
>I told you, man, home.

PIZZO
You live over there nigga.

TERRELL
You going to that Spanish chick house?

PIZZO
That's Juan lady, ain't it?

Chiron stops walking.

TERRELL
Oh yeah. That chick fine as fuck! Juan been dead a minute, that bitch give free head? Or she charge like Paula? Paula getting cheap though. A rock can get your rocks su—

Chiron grabbing Terrell at the chest, catches him by surprise, throws all his weight at him, drives him back and stumbling toward a fence.

Pizzo on him, kicks Chiron in the hip, jars Terrell free.

Chiron facing up on Terrell as he backs away, gets three, four feet between them, enough to keep both Terrell and Pizzo in front of him, fists raised.

Terrell shoots a long, heavy stream of spit at Chiron's feet, ridiculously masculine.

TERRELL
Faggot ass bitch, grabbin' my chest and shit, you see that shit Pizzo? Look like this nigga was comin' on to me. I ain't with that gay shit but if you fuck with me, I *will* fuck you. Give yo' ass more than you can handle, have you beggin' for your crackhead-ass mama.

> PIZZO
>
> Damn dog, you be like...
> ...gettin' head from the mama and the son at the same time.

> TERRELL
>
> At the same damn *time,* nigga.

The two of them laughing their heads off at this bit of brilliance. Chiron is still standing there:

> CHIRON
>
> Fuck you.

> TERRELL
>
> What you said? Say that shit again — I dare yo' ass, say that shit to my face, nigga.

> CHIRON
>
> Whatever, man.

> TERRELL
>
> Yeah alright — you better stay yo' ass right there if you know what's good for you. I mean dog — why yo' jeans so tight?

Terrell turns to Pizzo, clowning —

> TERRELL
>
> I mean real talk — you see how tight this nigga jeans be? Nigga nuts must be chokin' in them tight-ass jeans, boy I swear.

> PIZZO
> (laughing)
> Nigga nuts be like, "Can a nigga get a oxygen tank? We drowning down here."

Terrell and Pizzo clowning, laughing their heads off.

 TERRELL
 Night, *"Little."*

 PIZZO
 Haha, yeah — night night.

INT/EXT. METRO-RAIL - NIGHT - MOVING

Chiron asleep on Miami's much-neglected elevated train, head leaned against its faded cloth seats as it snakes its way above and through the hardened Liberty City.

From the looks of him, he's been here awhile. From the feel of him, resting wearily if peacefully, he may have slept through several loops of this train, back and forth from the blight of the hood to the glitz of Coral Gables and back again.

His head resting on the window, the lights of the train low. We hear the train wheels moving, the lights of the train flickering off and on... off and on, and... finally off.

EXT. COLLINS AVE - NIGHT - ESTABLISHING

From very high up, as though viewed from the roof of a condo. And *establishing* that a Metrobus is pulling away from here, having delivered Chiron to...

EXT. SOUTH BEACH, 27TH AND COLLINS - NIGHT

Chiron moving down a dimly lit side-street, Collins receding behind him, the beach growing louder ahead of him.

<u>We follow him</u>, moving along behind him as the sound around him

shifts, from the noise and chatter of care-free exhibitionism out on Collins... to the whispered loop of the ocean ahead.

As he nears the promenade separating the beach from Collins Ave and its endless resorts...

...he stops, takes a moment to look back. At what, we're not sure but, after a beat, he continues on, moves away from us and down into the darkness of the beach.

EXT. MIAMI BEACH, SHORE - NIGHT

Chiron sitting on the shore watching the moon and the stars over the ocean. The sky is clear and yet it's wild out, the wind whipping the reeds, ocean running waves upon the shore with verve.

Tonight, the sea seems immense, moon glowing blue, leaving the ocean a deep black that renders it boundless, entropic.

Chiron lost in it all, releasing his troubles in the presence of this nature when...

> VOICE (O.S.)
> You was waitin' for me?

Chiron turning, looks up into that voice, backlit by the bright beacon of a spotlight mounted on the promenade behind, unrecognizable at first, ethereal.

A shift in the light: *of course* it's Kevin.

> CHIRON
> Huh.

> KEVIN
> Nice to see you too.

Kevin smiles.

> KEVIN
> What the hell you doing out here?

> CHIRON
> What *you* doing out here?

> KEVIN
> You in my smoke out habitat, nigga.

A beat as something dawns on Kevin:

> KEVIN
> Oh shit, you come out here to smoke too, Chiron?

> CHIRON
> Something like that...

Kevin taking a seat on the sand beside him now, still smiling that incredible smile.

> KEVIN
> Man, you know you don't smoke. Why you pretendin'? You puttin' on a show for me, Black?

> CHIRON
> Why you keep calling me that?

A puzzled look from Kevin at first, then pulls a blunt from his pocket.

> KEVIN
> *Black?* That's my nickname for you. You don't like it?

A shrug from Chiron as a huge wave hits the shore, demanding their attention as it runs toward them, stops short a few feet.

Keeps their attention a moment: sound of the ocean, sound of the wind running through the reeds, the night...

Kevin sparks flame to that blunt:

> KEVIN
> You like the water?

Chiron says nothing.

> KEVIN
> Well let me introduce you to some *fiyah*.

Extends the blunt to Chiron:

> KEVIN
> Come on now. Ain't gon' bite ya'.

As Chiron takes the blunt, drags on it with Kevin watching...

CUT TO:

EXT. MIAMI BEACH, SHORE - NIGHT - LATER

Chiron and Kevin laughing their asses off, both high as hell, a joke or memory lost in the cut.

Whatever it was, extremely funny, so funny that as the two stop laughing those gleeful smiles remain, the two of them looking alternately from each other to the ocean and back, allowing themselves this bit of shared pleasure.

> KEVIN
> That breeze feel good as hell, man.

> CHIRON
> Yeah it do.

 KEVIN
Sometimes round the way, where we live, you can catch this same breeze. It come through the hood and it's like everything stop for a second 'cause everybody just wanna feel it. Everything just get quiet, you know?

 CHIRON
And it's like all you can hear is your own heartbeat, right?

 KEVIN
Yeah... feel so good, man.

 CHIRON
So good...

A long beat as that thought lingers between them.

The ocean.

 KEVIN
Hell, shit make you wanna cry, feel so good.

Chiron looking to Kevin now:

 CHIRON
You cry?

 KEVIN
Nah. But it make me want to.

Kevin flashing that big, cool-ass smile.

 KEVIN
What *you* cry about? You cry, Chiron?

Beat.

CHIRON
I cry so much sometimes I think one day I'm gone just turn into drops.

KEVIN
But then you could just roll out into the water, right? Roll out into the water like all these other muhfuckers out here tryna drown they sorrows.

CHIRON
Why you say that?

KEVIN
I'm just listenin' to you, nigga.
 (and)
Sound like somethin' you wanna do.

CHIRON
I wanna do a lotta things that don't make sense.

KEVIN
I didn't say it don't make sense.

Beat.

KEVIN
But tell me: like what? Like what lotta things?

CHIRON
Damn you nosy.

KEVIN
Uh oh. Look at Chiron cursing... You tryna get smart with me?

CHIRON
Whatever man.

 KEVIN
 (laughing)
 You trying to get smart?

Kevin reaching a hand to Chiron's neck, places his open palm there deliberately, with feeling.

 KEVIN
 You trying to get smart, Chiron?

Their eyes meeting here, Kevin slowly working his hand along Chiron's neck, small movement, with feeling.

 KEVIN
 Huh Chiron?

Slowly, nearly subconsciously, Chiron going weak, leans toward Kevin, their weight supporting one another here on the dune. All sound drowned by the echoing ocean, the night covering these two as close as they've ever been.

Both sit up again, facing each other and still close, noses nearly touching.

They stare.

These are waters they've never charted, the culmination of invitations they've been sending since day one.

Kevin smiles, his open lips brushing Chiron's. Chiron startles and... leans in.

Heavy this kissing, much deeper than just the meeting of lips. A moment more of this heavy petting, then...

...the sound of a buckle being undone, Kevin's hand disappearing down below, a gasp from Chiron and...

...pressure. Rhythm. Pressure and rhythm as Chiron's breath catches in his chest, head fully leaned to Kevin's shoulder, free hand grabbing at the sand as Kevin takes hold of him, a caressing and a pulling and a soothing as...

...Chiron comes, holding onto Kevin for dear life, choking on the sea breeze.

Kevin removing his hand, looks at the cum there before wiping it on the sand.

> CHIRON
> I'm...
> I'm sorry.

Kevin looking at him with the kindest, most open face:

> KEVIN
> What you got to be sorry for?

Chiron considering that. Honestly so.

The sound of the ocean.

INT/EXT. BOX CHEVY - NIGHT - MOVING

Chiron sits on the passenger side of this hood chariot, staring at all that passing neon and pastel of South Beach.

His face is pure, open.

> CHIRON
> Whose car this is?

> KEVIN
> Who you in it with?

MOONLIGHT

CHIRON
How you got a car?

KEVIN
With money, how else you get a car?
(and)
Boy I swear, for somebody who grew up in the hood you green as hell.

Kevin looking from the road, over at Chiron.

KEVIN
That's why I like you though.

Chiron looking out the window, blushing like a kid.

KEVIN
You live in the Beans, right?

CHIRON
Yeah.

KEVIN
What's wrong?

CHIRON
Nothing.

Chiron puts his head down. Kevin brings his fist to Chiron's chin. He pushes slightly so that Chiron raises his head.

KEVIN
You sure?

Just a nod from Chiron.

KEVIN
You never did nothing like that, huh?

A nod *no* from Chiron. Kevin smiles.

> KEVIN
> Yeah. I figured.

Off Chiron, CUT TO...

EXT. PAULA'S LIBERTY SQUARE APT - NIGHT

Kevin's car pulled up to the curb here, Chiron already out, leaned to the passenger side window.

A stilted moment, unsure how to play this.

> CHIRON
> Thanks for the ride.

> KEVIN
> No problem, Black. See you around.

Kevin extends his fist across this space, Chiron reaching in with his free hand to meet it. Their fists connecting and... holding there, just this bit of contact.

Chiron smiles.

> CHIRON
> Yeah... see you around.

Chiron turning from that Chevy, heading toward the near stairwell. We follow him, Chiron continuing on without looking back, the sound of Kevin pulling away down the block.

Chiron moving up the exterior steps of this Motel 6 — like complex, walking along the banister of the second story dragging his hand along the railing.

Reaches his door, gets his key in, holds the doorknob a moment, then, deep breath and...

...he opens it. Just a flash of an image: Paula crossing the living room left to right, hand pressed firmly, aggressively to her own skull, talking to herself.

Chiron unfazed, steps inside and closes the door behind him. Hold on this closed door, the sound of Paula yelling inaudibly behind it, then...

<div align="right">SMASH CUT TO:</div>

AN ALARM CLOCK

...blaring its synthesized squeal.

INT. HIGH SCHOOL, CAFETERIA - DAY

Chiron staring up at the clock as people push past him hurrying for the lunchtime lineup.

Typical high school cafeteria landscape, cool kids wedged into tables to *themselves,* jocks wedged into tables by themselves, band kids not eating at all, just air-playing their sets, particularly the drum-line, forever tabletapping.

And, of course, almost *everybody* is black.

Chiron moves through this mayhem, scanning the room for something, anything inviting. As he passes a group of girls, he spots Kevin sitting by himself.

Chiron's eyes light up but he checks himself, doesn't want to appear too obvious. He begins to take the longest route to get to where Kevin is but, before he can get halfway through his journey...<u>Terrell sits in front of Kevin.</u>

Chiron stops, diverts his attention before either can notice him, heads instead for the lunch-line (his hands have been empty).

OVER IN THE CORNER...

 TERRELL
Wassup, Kev.

 KEVIN
Terrell, what's good?

 TERRELL
Man a nigga don't see school no more.

 KEVIN
I hear you man.

 TERRELL
Lunch used to be the shit, though.

 KEVIN
Nah, the food wasn't never good.

 TERRELL
Nigga, I ain't talkin' bout the food. But that Friday pizza was the shit.

 KEVIN
 (Laughs)
Yeah I feel you on that.

 TERRELL
But back in middle school, you remember, we used to have some fun at lunch. Member, we used to play "knock down/stay down."

 KEVIN
Yeah my crazy ass was the king of that shit.

 TERRELL

Oh hell yeah I remember that shit. 'Member that white boy you fucked up?

 KEVIN

Cuban cat, right? Mauricio?

 TERRELL

Kevin you fucked that kid's face *up* man. We was calling you Tyson after that shit.

Kevin nearly blushing here.

 TERRELL

But nigga's don't do that no more. I mean. You know.

 KEVIN

What you sayin'?

 TERRELL

I'm sayin', you know, if I point a nigga out, you gone knock his ass down?

 KEVIN

That's the game ain't it? You dare me to swing on him and if I do, it's on you.

 TERRELL

Aight.
 (and)
Aight Kev. Let me see who ass gettin' dropped today.

INT. HIGH SCHOOL, COURTYARD - DAY - LATER

Lunch over, students begin to wander out of the cafeteria and into the adjacent courtyard.

We've not seen the full of this school yet. It goes like this: upon entering the guard gate and steps aforementioned, one enters what's best described as a tunnel, passing the admin suites and principals' offices and ultimately spilling into this atrium with three stories of classrooms above and around on four sides, the doors all facing *in* on this courtyard.

This building did not exist a decade ago; its older, decrepit predecessor demolished and replaced with this vision built most in the image of a prison, constructed by the same money and resources used to erect those spaces and ultimately with the same intention: to keep all who enter *watched* and *in*.

TERRELL

...leans to a stoop out here like a gathering storm, a group of boys milling around him and Kevin.

Pizzo is a part of this entourage too, laughing and pointing to various people as they pass, just loud enough for the circle of boys gathered to hear, all of them pointing and snickering, Kevin included.

A bright, Miami day, yet... a cloud falling over this courtyard — *a feeling* — this group scaring the other students in the area as a larger and larger swath of space surrounds them.

Eventually, someone in particular catches Terrell's eye: he immediately stops laughing, goes dark... at the sight of Chiron.

 TERRELL
 Kevin.

Kevin turns. So does Chiron. They stare at each other.

 TERRELL
 Hit that nigga, Kevin.

MOONLIGHT

Kevin looking at Chiron, meeting his eyes, still wearing the smile of this group-think, straining to.

> TERRELL
> Come on, Kev.

> PIZZO
> Hit that nigga, Kev...

> BOY 1
> Hit his ass...

> BOY 2
> Bitch ass!

> PIZZO
> Hit that nigga!

> TERRELL
> (at Kevin)
> What the fuck you waitin' on?

The boys have surrounded Chiron and Kevin. Kevin steps inside the circle, meets Chiron's eyes for the briefest moment...

...and wallops Chiron, the force of it rocking Chiron back, sends him down to one knee clutching his jaw.

> KEVIN
> Stay down.

But Chiron begins to stand up.

> TERRELL
> He want to get *up?* Knock his faggot ass back down.

Chiron taking a few steps closer to Kevin now, comes right up to him, meets his gaze, chin raised.

Beat. Eyes locked, then...

...POP, Kevin rocking Chiron again, Chiron staying on his feet though, defiant.

After a beat to gather himself, that same clear gaze from Chiron.

Terrell... is pissed. Socks Chiron.

It's open season now: the other boys pouncing, punches falling heavy like rain.

> KEVIN
> Stay down!

> BOY 2
> *Five-O, Five-O!*

The boys all separating quickly, slipping smoothly into the crowd as the Old School Guard and other authority figures appear, get to Chiron and pull him to his feet.

Chiron bruised and bloodied, cuts to his lip and nose, a gash above his eye. The Guard attempting to get his attention:

> OLD SCHOOL GUARD
> Who did it? Which of these niggas beatin' on you?

But Chiron silent, just staring across at Kevin, the boy returning his gaze, vacant.

The lunch bell rings.

INT. HIGH SCHOOL, PRINCIPAL'S OFFICE - DAY

Chiron sitting opposite PRINCIPAL WILLIAMS, 40s, serious but kind.

Williams just eyes Chiron up, can sense the anger simmering beneath the surface. Chiron stares at his feet, refuses to meet that gaze:

> PRINCIPAL WILLIAMS
> Chiron?

Nothing.

> PRINCIPAL WILLIAMS
> Chiron, listen: you're not in trouble. You're not being punished, okay? You did nothing wrong, we know that, okay?

Still nothing, Chiron has completely shut down.

> PRINCIPAL WILLIAMS
> Look, if you don't tell us who did this we can't press charges, understand?
> (and)
> All them damn kids standing around, all of y'all out there and don't nobody got the heart to say who did it?

That getting Chiron's attention, head snapping to meet Williams' gaze:

> CHIRON
> You don't even know.

> WILLIAMS
> Oh I *don't?* You think all this just started, boy?

> CHIRON
> I ain't no boy.

 WILLIAMS
 Hell you ain't: if you was a man it'd be four other
 knuckleheads sittin' right there with you.

Chiron looking away again out a window there, done with this:

 CHIRON
 (low, breaking)
 You don't even know.

Williams taking him in again now, looking further, looking better, sees things in Chiron he'd not seen before; sees him:

 WILLIAMS
 Look son, I'm not blaming you, I'm not. I know
 it's hard, believe me, I'm not tryna disrespect your
 struggle. I just need you to know, if you need some
 help, if you need somebody to talk to that door
 right there, it's always open, you feel me? And as
 soon as you walk through it, let me tell you —
 everything you going through, all of it's gonna get
 better.

Ignoring that, still set on that window.

 WILLIAMS
 You feel me?

Off Chiron meeting Williams' gaze, CUT TO…

INT. PAULA'S LIBERTY SQUARE APT, BATHROOM - NIGHT

Chiron taking in his own image in the bathroom mirror, left side of his face bruised and swollen, that cut at his right ear clotted with blood.

He runs water into the basin and, looking down into it, we notice

that it's already filled with something, a pool of ice.

Chiron lowering his face to the water, submerging his head in it for the longest moment, long enough to make the silence uncomfortable, then...

INT. PAULA'S LIBERTY SQUARE APT, KITCHEN - NIGHT - LATER

Paula sitting at the kitchen table, a dying cigarette in an ashtray there. She looks beyond exhausted. And fried.

Chiron appearing with glasses of water, sits one in front of each of them.

We leave them this way: neither drinking those waters, neither speaking, then...

INT. HIGH SCHOOL - DAY - MOVING

Chiron passing the Old Security Guard, entering the building.

We continue with him, up a flight of steps, into the cavernous tunnel of the school entrance.

All eyes looking in at Chiron, in at us.

And the SOUND, so many shifting ticks and voices, whispers accompanying those looks, adolescent energy unhinging itself.

Chiron entering a stairwell, rising, pushing past other kids toward the second story of this building.

Reaches it, steps onto the landing and slips into one of the interior passageways, the sound of those voices and whispers amplified, echoed and refracted off the metal lockers and industrial design.

But Chiron's face? Unchanged, still that blankness, that pensiveness. With him all the way as we lead/follow him around a turn, toward a door and into...

INT. HIGH SCHOOL, CLASSROOM - DAY - CONTINUOUS

Chiron entering, moving directly to his seat, a wooden chair there.

Sets his bookbag atop his desk, takes the chair, slides it from the desk and...

...brings it down atop Terrell's head.

CRACK!

Terrell spilling to the floor; no blood, no movement, a total collapse to the spot where he sat.

Beat.

Everyone in the class in shock, nobody moving, all eyes on Terrell. He's not moving, not breathing, body prone on the floor. A beat, then...

...he spasms back to consciousness, a quick convulsing and then a reach for his head.

Chiron raising that chair, brings it down on Terrell again, the boy jolting with the impact.

Pierce sets upon Chiron. A few others help restrain him.

INT/EXT. HIGH SCHOOL - DAY

Police lights flash on the school's walls. Kids all stand outside as well as teachers.

Chiron is brought out of the school in handcuffs, led by two officers, staring and muckraking from the gathering as he passes.

Gets down to the street, is ushered into a police car. As he stares out from the backseat, a face at the top of the steps stares back: Kevin.

<div align="right">CUT TO BLACK.</div>

First, OVER BLACK, a beat of SILENCE and, immediately after, a gasp for air, then...

<div align="right">FADE IN:</div>

...on a grown man covered in sweat.

INT. BLACK'S APT, BEDROOM - NIGHT

BLACK (the same Little/Chiron character but late 20s now), sitting upright.

Eyes open, staring off into the light spilling through the window-pane above this bed.

INT. BLACK'S APT, KITCHEN - NIGHT

Black standing at the kitchen sink.

The faucet running in the sink before him and, looking down into it, full of ice cubes, plastic trays from a freezer somewhere nearby.

Takes a towel, dips it into the water, wrings it slightly. Brings it to his face, covers his eyes, his forehead gently with it.

Dips it into the basin again, wipes across his chest. Slowly, he lowers his torso to the sink, submerges his face completely.

INT/EXT. CHEVY IMPALA - DAY - MOVING

Hot today; *hot as hell out today* as Black sweats through baggy jeans and oversized white tee.

What's more, unlike the pensive Black glimpsed recovering from a fevered dream, this one menaces through a full array of gold-fronted teeth.

They're impossible to miss as the city passes by outside his window, cruising through the Flats.

As the car continues along, we go CLOSE ON: Black's license plate. The vanity spelling BLACK is interesting, but that it's issued in the state of Georgia is more important.

INT. ATLANTA AGAPE REHAB CENTER - DAY

Black sitting in the reception area of this rehab clinic. He doesn't look lost here and yet... he doesn't look comfortable, dressed in a conservative, button-up shirt.

Two or three others sit on simple chairs beside him, all of them waiting. Finally, from somewhere across the room:

> VOICE (O.S.)
> Chiron Harris?

At the sound of his name, Black rises, moves toward that voice.

EXT. COURTYARD, ATLANTA AGAPE REHAB CENTER - DAY

Black sits in front of PAULA (40s now, hair pulled back, thinned but a light in her eyes that wasn't there before).

MOONLIGHT

Paula looks down and goes into her pocket, pulls out a cigarette.

Lights it, almost puts it in her mouth when she stops and stubs it out.

 PAULA
Quittin' that too.

Black just nodding, indifferent.

 PAULA
Trying to, at least.
How you been?

 BLACK
Alright.
 (then)
I ain't sleepin'.

 PAULA
Why not?

Awkward.

 PAULA
Right. If you knew you'd prolly...

 BLACK
Bad dreamin'.

 PAULA
Still?
You ever thought about talking about it with somebody? I mean. You know, not even like a counselor. Maybe somebody like, like your mama?

Paula laughs, makes light of it. Black still unmoved. Hard to tell which of these two is in rehab and which isn't.

PAULA
Yeah it sound funny to me too. But I am your mother, ain't I? You can talk to me if you want to. Or at least *somebody*, you got to trust somebody, you hear?
	(then)
You talk to Teresa?

BLACK
Yeah.

PAULA
(Shrugs)
Good.

Paula mimics Black's shrug...

PAULA
"Good."

...face curling into a beautiful, teasing smile. Hard to not love this woman, hard to not give her infinite second chances.

BLACK
When you go home?

PAULA
Home?
	(beat)
This *is* home. I mean... they 'lowin' me to stay and work as long as I like. I figured, you know, might as well help other folks, keep myself out of trouble.

BLACK
That's good, Mama.

 PAULA
 Yeah... I think it is too.
 (a deep breath)
 I really do.

Black nodding his head silently, looking away from his mother, over at another mother and son performing this same ritual across the courtyard, down at the stubbed cigarette still clutched at his mother's lap.

Paula taking a real good look at her son. Something in her face softening at the sight of his hardened jaw, those gold fronts.

 PAULA
 So...
 (beat)
 ...you still in them streets?

Nothing from Black, eyes shifting to the ground now, down and away.

 PAULA
 Didn't come all the way the hell to Georgia to have you fall into the same shit, Chiron.

 BLACK
 I'ma go.

 PAULA
 No, you gon' listen.

 BLACK
 To who, you?
 Really, though?
 You?

Black pushing back from the table, rising. Paula grabbing his hand

before he can turn, hard as he is, his mother's touch an instant pause, stands still staring at that ground:

>PAULA
>Not like this, baby.

And...

>PAULA
>*Not like this.*

Black looking down, looking away, looking anywhere but at Paula. Black returns to his seat, eyes fixed to a spot.

>PAULA
>I messed up baby. I fucked it all up, I know that. But yo' heart ain't gotta be black like mine, you hear me? I love you baby. I do, I love you, Chiron. You ain't gotta love me, lord knows I didn't have love for you when you needed it, I know that. So you ain't gotta love me but you gon' know that I love you, you hear?

Nothing from Black.

>PAULA
>You hear me, Chiron?

Paula yanking that arm.

>BLACK
>Damn Mama, yeah.
>>(and looking to her now)
>I hear you.

Paula taking up that cigarette again, lights it this time. A big, deep drag. Savors it, pulls all of it deep down into her chest.

PAULA
One step at a time, baby.
One step at a time.

CUT TO BLACK.

And over BLACK, the TITLE CARD:

BLACK
III.

MOONLIGHT

INT/EXT. CHEVY IMPALA - DAY - MOVING

Noise and fuzz in here, quads and subs as Black blasts something bass-heavy yet moving, think Erykah Badu Chopped and Screwed.

All elbows and mean mugs as he leans at an angle, seat reclined way back with lips parted to show those fronts; eyes scanning the blocks and corners he's passing as much as the road he's driving.

A moment of him driving this way, then...

INT./EXT. BLACK'S CHEVY IMPALA - NIGHT - MOVING

Moving with Black as he turns off the main road, pulls into his apartment complex.

As he makes his way through the parking lot, a figure appears ahead of him, a young guy rising from a stoop, caught in the glare of Black's headlights.

Black heads directly for the young guy, then turns away from him, into his parking spot.

INT. BLACK'S APT, LIVING ROOM - NIGHT

Black on the couch, that same white tee from before but in shorts now, flip-flops at his feet. Travis (early 20s, green, the "young guy" from the parking lot) stands before him, hands clasped together behind his back.

Dim in here, a table lamp bathing Black's slate skin in orange warmth, television raking Travis in a cool blue. So dim, in fact, we hardly notice the work going at Black's lap: bills unfurled across disparate bills.

Black counts. Travis watches.

An extended beat of this, Travis' eyes down at his feet as Black nears the end of his count. Finished, he raises his head, brings his gaze to meet Travis'.

> BLACK
> You short, Travis.

Travis' brow arching with confusion.

> TRAVIS
> Wait, what?

> BLACK
> You short.

> TRAVIS
> Nah, I counted it, it's all there, it's all there on my mama life. You trippin'.

> BLACK
> I'm *what?*

Pause.

> TRAVIS
> I ain't mean it like that.

> BLACK
> Then how you meant it?

> TRAVIS
> I mean, I...

Travis trails off there.

> BLACK
> Where the rest of the roll?

Travis thinks for a second — maybe he *is* short, maybe his count is off, but... he straightens, chin up:

> TRAVIS
> It's all there. You might could think I'm short... but when I handed it to you, it was all there. That's on my mama.

> BLACK
> You sayin' I'm a liar?

> TRAVIS
> I ain't say that.

> BLACK
> Then what you sayin'?

> TRAVIS
> I'm...
> I mean...
> Dog, I'm just —

> BLACK
> You just what?

Travis goes quiet, eyes at his feet — he's fucked. Black lets him stew a minute, then... breaks into a toothy grin.

> BLACK
> Nah. Just fuckin' with you.

> TRAVIS
> *Huh?*

> BLACK
> Count good. You did good — did real good.

Black extending a few bills toward Travis, waiting as the boy nervously takes them from him.

> BLACK
> Can't be on the corner if you can't take a nigga just fuckin' with you.

Travis nods. Black extending a few more bills toward him, waiting as the boy nervously takes them.

> BLACK
> Heard you been in them dice games, too. Watch yo' back with them folks. Be better off at jai lai, dice game bring nothin' but pain.

Travis wrinkling his face at that:

> TRAVIS
> What the hell is "high lie"?

Black begins to explain, but... just smiles.

INT. BLACK'S APT, BEDROOM - NIGHT

Surprisingly, Black fast asleep, resting peacefully under the whir of a small fan.

A moment of him sleeping, then... his phone comes to life, vibrating on the bedside table. Black rolls over groggily, silences the thing with a flick of the wrist.

After a beat, a second, shorter vibration pierces the quiet. Black retrieves the phone. As he does...

BEGIN MONTAGE:

INT. BLACK'S APT - NIGHT

QUICK IMAGE: Black moving about the apartment in just his boxers.

> AUTOMATED VOICE (V.O.)
> *You have... one... new message.*

INT. BLACK'S APT, KITCHEN - NIGHT

QUICK IMAGE: Black standing before the open freezer door, head halfway in to absorb the cool air.

> PAULA (V.O.)
> Chiron, this your mother. I know it's late but figured you ain't never been one much for sleep. Wanted to thank you again for comin' to see me.

INT. BLACK'S APT, BATHROOM - NIGHT

QUICK IMAGE: Black in the bathroom, a repeat of his earlier ice basin ritual.

> PAULA (V.O.)
> That was... that was good of you. Hope you gettin' some rest baby.
> (and)
> Hope you come by again soon.

CUT BACK TO:

INT. BLACK'S APT, BEDROOM - NIGHT

And it's as though he never left: flat on his back above the covers, staring up into nothing, the phone there on the bedside.

An extended beat of quiet here, enough to see this is a man who wrestles with his mind at night, then...

...the phone buzzes again, Black reaching for it instinctively, grabs it without bothering to see who it is and:

> BLACK
> Ma, it's late, I'm tryna sleep, I got your message.

Beat.

We can hear the other side of this connection. For now, it's just the white noise of dead air, whoever's on the other end keeping to themselves, then...

> VOICE (O.S.)
> (through phone)
> Hello?

Black pulls his phone from his ear, checks the display. It's a 305 number: Miami. His demeanor shifting at the realization.

> VOICE (O.S.)
> Eh Black, I mean... Chiron, man.

Black slowly sits up, just up on his elbows there, brings his chest up a bit:

> VOICE (O.S.)
> How you doing? This... this Kevin.

Kevin. Black's face startling, though only so much, such a contained man.

						KEVIN (O.S.)
You there? Say somethin', nigga.

						BLACK
Yeah.
		(and)
Hey.

						KEVIN (O.S.)
Long time no see, right? I asked Teresa if she had your number and... I'm workin' this job, man. Lotta people comin' by and this dude, he come by today — made me think of you.

Beat.

						KEVIN (O.S.)
You there?

						BLACK
Yeah, I'm here.

						KEVIN (O.S.)
You remember me?

Black looking about himself, around this room before answering. Looks more into his memory than anything else: *Yes, he remembers him.*

						BLACK
Yeah. I do.
Been a while.

						KEVIN (O.S.)
Yeah.
It has.
		(and)
Where you at?

Black closes his eyes.

> BLACK
> Georgia.
> Atlanta.
> Been up here ever since...

> KEVIN (O.S.)
> Yeah, that's what I heard.

Beat.

A very long, very dense, very quiet beat.

> KEVIN (O.S.)
> I'm... I'm sorry about that... about *all* that, Chiron.
> (and after a pause)
> About all that shit what went down, man.

Black looking about himself, about the room, eyes wandering and drifting, had pushed so much of this away.

> KEVIN (O.S.)
> Real shit, dog, I *am*.

A sound from Black into the phone, not so much a word as a gesture, guttural, ambiguous, not affirming but a reprieve, an allowance for the space to continue.

Finally, mercifully:

> KEVIN
> What you doin' up there?

 BLACK
 (coming back)
 Not much.
 (and)
 Just trouble.

INT. JIMMY'S EASTSIDE DINER - NIGHT - SAME

Simple this place, KEVIN (late 20s now) dressed in a chef's apron behind a staging station, from the looks of the kitchen surrounding him, a diner-type place, short-order cook.

 KEVIN
 Chiron and trouble *always* found a way.

Out beyond the staging station Kevin's leaned to, an old-school register, tan-colored tabletops and matching vintage booths.

This is one of those relics that will always be a part of Miami. When the tide finally sweeps the city into the Atlantic, the last note rising from it will be Compay Segundo's "Chan Chan" reverberating from this place.

INTERCUT BLACK AND KEVIN

 BLACK
 Yeah... something like that.
 What about you?

 KEVIN
 I'm a cook, man.

A loud laugh from Black, the clear joy of it a jolt.

 BLACK
 You a *cook?*

 KEVIN
 Yeah man, got sent up for some stupid shit, same
 stupid shit we always get sent up for. Put me on
 the kitchen line and I kinda took to it.

 BLACK
 Greeeeaaaaaaaaat day, Kevin Jones: Chef
 Boyardee.

 KEVIN
 I cook better than that shit.

 BLACK
 You better or your ass won't be cooking long, feel
 me?

The two of them laughing there, the familiarity clear, asserting itself.

 KEVIN
 Yeah, so... I just thought about you man. There's
 a jukebox in here, folks come in and play they
 songs and that's the music we get in here. This dude,
 man...

Kevin trailing off there, thoughts wandering, eyes drifting over to that jukebox, one of the old-school types with actual CDs and pages that flip when commanded.

 BLACK
 Yeah...

 KEVIN
 ...this dude reminded me of you.

Beat.

MOONLIGHT

> BLACK
> What'd he play?

A long pause from Kevin, the song wedging itself in his thoughts right now, pushing everything aside.

> BLACK
> That good, huh?

> KEVIN
> Yeah...
> ...that good.
> (and)
> If you ever come down here, man, you holla at me.

> BLACK
> This your number?

> KEVIN
> Nah, no cell. This the diner. Right now it's better if folks can't reach me. I tell niggas, "Call my momma house if you really need me," otherwise I'm only 'bout this J-O-B.

> BLACK
> True.
> What's the name of the place?

> KEVIN
> Jimmy's Eastside Diner. If you ever in town, Chiron, I mean it. Come on by, I'll cook you somethin', play that song for you.

Black fully sat up on the bed now, free hand to his temple, the other clutching his cell to his ear. Just the sound of his light breathing.

> KEVIN
> Alright Chiron, be easy.

Click.

Black lowering his phone now, staring at the screen, the simple information there: *Call Duration: 5min 29secs.*

A lifetime.

> CUT TO:

INT. BLACK'S APT, BEDROOM - DAY

A moment of stillness: Black prone atop the covers, just his boxers and still a small sheen of sweat. From the look of him, jaw slack, lips parted just so, this has been a restful sleep.

Slowly, after a beat to watch him this way, Black stirs slightly, a slowed wakening.

Stretches now, body turning, arms reaching beyond this bed, extending toward the light streaming through the lone window there.

Turns on his side. Is about to sit up but… stops. From the look on his face, a realization: he reaches to his crotch.

INT. BLACK'S BATHROOM - DAY

Black standing before the basin, hands working at something in the water.

No ice, no towel. Instead, he's standing over a muddied plume, a layer of soapy foam atop the surface: he's handwashing his boxers.

An extended beat of this washing, then…

...the SOUND of music blaring, all highs at first, a rattling trunk following.

INT/EXT. CHEVY IMPALA - DAY - MOVING

Black in mode again: gold fronts, white tee, one hand on the wheel as he pushes through these streets.

Eyes scanning the corners and alleys he's passing, whatever's out there getting little from him, just this glare.

INT/EXT. CHEVY IMPALA - DAY - MOVING

Black hanging a U-turn, neck craned all the way around to keep an eye on something outside this car.

Headed back the other direction now, he pulls over to the side of the road, honks his horn, three sharp beeps, and...

INT/EXT. CHEVY IMPALA - DAY - MOVING

Black at the wheel, Travis in the passenger seat beside him.

On Travis' lap, a mix of cash and baggies, a greasy, crumpled brown bag wedged between his thighs. He's counting.

The music blasting as always in here, Black nodding his head to an old-school Goodie Mob track, then... cutting the music sharply, face going slack as...

...a patrol car passes in the opposite direction, Travis never breaking his count, Black cranking the music, and...

CUT TO:

TRAVIS

...head cocked to the side, a posture of listening.

INT/EXT. CHEVY IMPALA - DAY - PARKED

Black parked at the edge of an alley, looking out at Travis standing among two other young men.

We can't hear what's being said down there, the whole thing viewed from Black's vantage.

Instead, all long-lens gestures: Travis going through some form of count with his fingers, the two young men bringing their hands to their chests *(Who? Me?!)*, the posture of explaining.

Black reaching to the floorboard beneath him,, retrieves the obvious: a .38 Special.

Takes another look down that alley, then... opens the door, steps into the alley and begins toward them.

We don't follow, just watch from this distance, then...

INT. BLACK'S APT, BEDROOM - DAY

Dangling from a wire hanger, panning with the flow of an oscillating fan: the underwear we'd seen Black wear before, still damp in the humid air.

REVERSE ANGLE: BLACK'S FACE, eyes fixed on the underwear, studying them with a mixture of shock and reverence.

Reaches a hand to them, takes their short hem in his hands, partly to gauge the dampness, partly for wont of touching them.

MOONLIGHT

Something on his mind here, thoughts turning and turning and turning. He checks his watch: half past one.

INT/EXT. CHEVY IMPALA - DAY - MOVING

Observing him through the front windshield of this car, the whole of it viewable from here.

Just the sound of the road, no music, certainly no speaking as Black drifts along what appears to be a highway.

A look of resolution on his face, a peace, a clarity. The image closing in on him now, a slow, subtle zoom pushing in on that face, those eyes.

Just as we near the end of this move, our view pivots, panning away from that windshield, perpendicular to our traveling: nothing but mangroves out there. And across a large median, lanes of other traffic running in the opposite direction.

There's no doubt now, this is not a drive around Atlanta. The speed and highway surroundings should make it clear: he's going much farther.

An extended beat of this traveling, of the road and trees and wind, the speed of the passing land and soundscape escalating, building, the whole of it coalescing into a hypnotic rhythm, then...

WAVES

...both the sight and sound of waves crashing, lashing at the shore.

EXT. MIAMI BEACH - NIGHT

A muted, wide base to the light, waves rushing onto shore under the watch of a full moon.

There are children at play, a dozen at various ages, all black, seven to fifteen years old.

None of them in proper trunks, most in homemade cutoff shorts and Fruit of the Loom white tank tops. All laughing as the waves rush at their feet, a few feigning fear at the ocean as others — the boys mostly — drag them into the surf.

We watch the children at play a moment longer. We've seen none of these kids before, we'll see none of them again.

A final beat of this, then...

EXT. JIMMY'S EASTSIDE DINER, PARKING LOT - NIGHT

A door closed — Black's car parked deep in the corner of this parking lot, in the farthest back corner away from street light, obscured by low-hanging shade trees.

The diner is away from us, across the parking lot. Black takes it in a moment, pulls on a fresh shirt.

He's moving, crossing the parking lot at an easy clip. It's quiet out, a few passing cars to Black's left running north on Biscayne Boulevard, no foot traffic — can hear the SOUND of his footfalls on the pavement.

As he nears the threshold of this diner, takes the handle on the entry...

CLOSE ON: an old-school bell, the sound of it jingling as the door it's affixed to parts.

INT. JIMMY'S EASTSIDE DINER - NIGHT - CONTINUOUS

And right away, the sound of music, something old, soft and lilting

(think Aretha Franklin's "One Step Ahead").

Black scanning this room, his view of the place a clue for us: this is definitely the same diner we saw Kevin working in during the earlier phone call.

All the details are there, the old-school register, vintage chairs and tabletops. And in the corner, that old-school jukebox blessing us with Aretha.

BLACK

...on the move now, crosses the diner with eyes down and ahead of him. There's a counter lined with stools, directly opposite the staging station and adjacent the register.

Black eases up to the counter, places his cell atop it and takes a seat.

No one stirs at Black's movement, no one watches. Looking about the place again, we notice the other patrons: a quartet of college girls in a corner booth shoring up for a night on the town, an elderly gentleman sitting to himself, staring into a cup of mild coffee.

As Black watches the elderly gentleman...

> VOICE (O.S.)
> (moving)
> Be right with you.

A figure moving past, carrying an urn over to the old man, sets a new cup down and pours a fresh coffee, scoops up the old cup as he moves on.

As he crosses to the girls, we see him better: it's Kevin.

We watch as he speaks to them; can't hear any of it but from the feel of it, very jovial, Kevin is good at this work.

A beat of watching Kevin here, isolated bits of him from Black's perspective: Kevin's lips as he speaks, the hand he rests to his neck instinctively.

Finished with the girls, Kevin turns back toward the counter, hands full with their spent dishes. As he approaches, he looks right at Black, right at us...

 KEVIN
 (moving)
 Be right with you, boss, just let me get this out the way.

...and moves past.

Somehow, Kevin has not noticed him.

Something lodged in Black's throat, without thinking places his hand there: *Am I breathing?*

He must be, he'd better be: those dishes discarded somewhere in the back and... here comes Kevin.

 KEVIN
 How you doin' tonight, what can I get you?

Kevin flipping through a stained note-pad, hasn't bothered to look up yet. As he does, his eyes settle on Black's.

Beat.

Kevin watching this man. And Black watching back, the two of them silently holding each other's gaze, pure curiosity. Kevin's head cocking to the side now:

 KEVIN
 Chiron?

Nothing from Black, just those eyes. Kevin lowering that notepad, rounds the counter, comes right up beside him. On Kevin's face: no doubt who this is.

> KEVIN
> *Damn man* why you ain't say nothin'?!

Kevin taking Black's right hand in his, pulls him in close and throws his left arm around his back: warm, tight, *masculine*.

The embrace held, Black slowly reciprocating, his left arm cautiously placed around Kevin's back and, subtly, moved there, close but not quite a caress.

The men part.

> KEVIN
> Damn Chiron.

> BLACK
> 'Sup, Kev'.

> KEVIN
> What the hell you doin' here, I mean...

Kevin trailing off there as Black nods agreement, gets the oddity of his own actions.

> KEVIN
> Well shit, you here now, that's all that matter.

Again, that nod from Black, Kevin smiling in reply:

> KEVIN
> There go that damn noddin', you ain't changed a bit, still can't say more than three words at a time, huh?

A smile from Black. This guy gets him.

> BLACK
> Said you was gon' cook for me, I know how to say *that*.

Kevin rounding that counter again, Black clocking him as he goes, winds up opposite him, takes up that notepad again.

> KEVIN
> Yeah I did, man. I did. What you want? You can pick from the menu or I can give you the chef's special.

Black watching Kevin across this counter.

Over on the jukebox, that song ends, just the muted sound of the girls in the corner there, nothing but this short space between them.

Kevin sets his notepad down.

> KEVIN
> Yeah.
> We here, Chiron.

As Kevin heads for the kitchen, leaves Black with that thought...

CUT TO:

INT. JIMMY'S EASTSIDE DINER - KITCHEN

...all hands and handles, a cast-iron skillet going over an open flame.

INT. JIMMY'S EASTSIDE DINER - NIGHT - LATER

Black on his stool at the counter, watching through the staging

station as Kevin works over that flame.

Behind him, the group of girls moving toward the exit, bell jingling as they step onto Biscayne.

Black's gaze lingering on them a moment, tracking them as they push farther and farther into the night. Coming back, his gaze settles on the table across the diner: the old man, that cup of coffee.

Black rising now, digs down into his pockets, pulls the bit of cash and change there. Begins across this space, over to the jukebox.

Gets to flipping through the flaps, four to a side, scanning left and right. A bit more flipping until... *bingo.*

A string of quarters, a few buttons pushed then...

...the click and clack of the machine, a disc racked and spun to speed, so quiet in here without that jukebox, then... the SOUND of a disc racked, the jukebox doing its work as...

 KEVIN (O.S.)
 Chef's special.

Black spinning to find Kevin passing, moving behind him with a freshly plated meal — carries it across the diner floor, over to the booth abutting the diner window.

Black cocks his head in surprise, makes his way over to —

THE BOOTH

Approaches a smiling Kevin, takes a look at the plate he's made for him: black beans, white rice, a grilled chicken breast with mole coating.

 BLACK
 So you *Cuban* now?

> KEVIN
> Only in the kitchen, Papi.
> (and)
> Sit down, nigga. Or you gon' eat standin' up?

Black complies, eases into the booth, eyes the food.

> KEVIN
> Want a drink?

> BLACK
> I don't drink.

A huff from Kevin — more playful than skeptical — leaves the booth, heads back over to the counter. Black watches as Kevin roots around for something, comes back over with a half-run bottle of red wine, something simple.

Sets a water glass down before each of them, settles in across from Black, pours.

> KEVIN
> Nigga I ain't seen you in like a decade, you gon' drink with me.

Black just looking at this guy: *What can he do?*

The clink of glasses, Kevin taking a sip of his, Black taking a gulp, maybe he *doesn't* drink after all.

Kevin settles his elbow and forearm to the table:

> KEVIN
> So what bring you here, Chiron?

Curious, innocent, suggestive, all at once. Black just watching Kevin in response.

 KEVIN
 Eat your dinner man.
 (rises)
 Eat your dinner.

Black's gaze following Kevin as he replaces the old gentleman's coffee as before, moves on to a young couple sitting in the booth where the group of girls were.

Off Black, CUT TO...

INT. JIMMY'S EASTSIDE DINER, BOOTH - NIGHT - LATER

Later by the look of Black's plate, completely empty.

Black takes up his water glass of wine, a second bottle open there beside the first — they've been thirsty.

Kevin appears, settles in again.

 KEVIN
 You remember Samantha?

 BLACK
 (nodding)
 Yeah, I remember her.

Kevin reaching into his wallet, takes out a photo, places it on the counter:

 KEVIN
 Kevin Jr.
 Me and Samantha. Had him young; *too* young.

Kevin watching as Black takes up the photo, brings it close, examines it.

> KEVIN
> When I got locked up, man. It was hard. *Real* hard. Had me in state, not that county shit. That's when I knew I had to find somethin'. That's when I started the cookin' thing, knew I couldn't go back to the street, not after that.

> BLACK
> Y'all still down?

> KEVIN
> Me and Sam?
> (beat)
> Nah. We still cool though, gotta be for Lil' man, but... nah, not like that.

Beat.

> KEVIN
> What about you?

> BLACK
> What *about* me?

> KEVIN
> Nigga, tell me somethin', what you doin', *who* you doin'?

Black going sheepish at that last part.

> KEVIN
> C'mon nigga, I'm waitin', done cooked for your ass and everything, shit, these grandma rules you know the drill, you gon' eat, you gotta speak.

Black thinking on this, weighing something. Takes another sip of his wine, then...

> BLACK
> Alright, straight up? I'm trappin'.

> KEVIN
> (serious)
> *What?*

Black just nodding.

> BLACK
> When they sent me up to Atlanta, put me straight into juvie for beatin' old boy. Met this cat in there, when I come out, put me on the block. Did good at it. Rose up.

Black shrugging his shoulders, no explanation, no excuses.

> BLACK
> It is what it is.

> KEVIN
> Bullshit, it ain't what it is, Chiron, that ain't you.

> BLACK
> Nigga you don't know me.

> KEVIN
> Oh I *don't?*

Beat.

> BLACK
> I'ma get my shit straight.

Kevin shooting Black a look:

 KEVIN
 And I guess gettin' your shit straight is drivin' twelve
 hours down here for no reason?

Kevin looks over his shoulder — the young couple is up at register, waiting.

Black watching as Kevin heads over, begins ringing their bell. It's a small moment, cordial — Kevin smiling, making small talk with the husband and wife. He's good at this.

The sound of that familiar door jingle on their exit, Kevin beginning back now, stops to bus the couple's table — arms loaded with plates and silverware as he passes...

 KEVIN
 (moving)
 And why you got them damn fronts?

...doesn't bother for a reply, just keeps moving into the kitchen.

Beat.

Black alone again for the moment. It's dead in here — no couples, no groups of girls. Kevin is nowhere to be found, there's nothing between Black and the door.

The door.

Black watching the door as...

Kevin reappears, wiping soap foam from his forearms, heading back over. Takes his seat again across this modest booth.

Kevin's thoughts going back to this conversation, the two of them separated by this table; by *only* this table. It's as though they can sense this, both mulling their thoughts, fingering those water glasses.

Black's eyes lifting:

 BLACK
 Why'd you call me?

 KEVIN
 What?

 BLACK
 Why did you *call* me?

Beat.

 KEVIN
 I told you, this dude came in...

 BLACK
 Yeah...

 KEVIN
 He played this song...

Kevin trailing off there, eyes going to the jukebox in the corner. Lets his gaze linger a beat, then...

...roots around a tip jar beside the register. A moment later, he's rounding the counter, heading for...

THE JUKEBOX

...Kevin nearing it, studying a moment before flipping those pages, one after another as Black had before.

From the effort, he does not know what he's looking for. Or rather, he's searching for it, unsure.

BLACK

...watching, looking on as Kevin hovers his finger over those pages, tracing a line along the glass there, mouthing something to himself until finally...

...Kevin's got it: the click of the jukebox, articulating arm shifting, a disc whirring to life and...

Church, juke joint, cabana: the place where the three meet and meld as the opening organ of Barbara Lewis' "Hello Stranger" fills the air.

> *Hello, stranger*
> *It seems so good to see you back again*
> *How long has it been?*
> *It seems like a mighty long time*

KEVIN

...leaning his back to the jukebox, arms folded.

AT THE BOOTH

...Black sitting sideways, meeting Kevin's gaze as he's listening.

Both watching each other, eyes linked, locked.

<u>Black's eyes in particular here</u>, perhaps from Kevin's perspective, drifting into them: he's opening, *he's letting Kevin in.*

A beat as the song continues. The second verse:

> *Ohhhhhhh, my, my, myyyyyy*
> *I'm so glad*
> *You stopped by to say "Hello" to me*
> *Remember that's the way it used to be*
> *Ooh, it seems like a mighty long time*

It's on the nose, yes, but fuck it: *reminded him,* like a punch flush

to the face, forever and always a reminder of this thing, of everything.

Kevin crossing the diner floor, closing the space between them. Settles to the booth again, leans back. He watches Black, but...

...as the song continues, Black's mind drifts elsewhere, mouth agape as Barbara continues...

> *Ohhhhhhhhh*
> *If you're not gonna stay*
> *Please don't tease me like you did before*
> *Because I still love you so, although...*
> *It seems like a mighty long time*

The two of them this way as the song continues, Barbara *ooooing* and *ahing* her way through the last few bars as the men listen, nothing else in the world but this moment.

The song ends.

Over at his table, the older gentleman pays them no mind, simply sips his coffee.

Off the DOORBELL JINGLING...

EXT. JIMMY'S EASTSIDE DINER - NIGHT

Black standing with his hands in his pockets as Kevin works at the door behind him, closing down the diner.

Down the sidewalk from them, the older gentleman moves away, labored step after labored step.

Finished, Kevin turns to Black, the two falling into step without a word, moving across the parking lot — Black leading, Kevin just behind.

Occasionally one looking to the other as they go, much said in these eyes and looks, but... just the sound of movement, a heavy key ring dangled at Kevin's side, the whir of Vespas roaming up Biscayne.

Kevin a few steps behind as Black nears the driver's-side door. Like anyone seeing this gaudy thing for the first time, Kevin is taken aback.

> KEVIN
> This you?

Black toggling the alarm system, the Chevy beeping loudly, all lights flashing twice and a piercing beep from that sound system.

> KEVIN
> You wasn't playin' bout them traps.

A shrug from Black as Kevin takes the passenger-side door, gets in.

Black following, the engine on the car coming to life.

A BEAT as the car eases away from here, reaches the edge of the parking lot, pulls into traffic.

INT/EXT. CHEVY IMPALA - NIGHT - MOVING

Loud in here, part habit, part defense mechanism: little room for words with two cabinets and a sub pushing Slim K's "Purple Haze" remix through these speakers.

Black leaned into the driver's-side door as always, one hand on the steering column, other resting on his lap.

Nothing spoken between these two for a beat, just clocking each other on the sly as the passing lights of the streets and storefronts play on their faces.

MOONLIGHT

Black reaches for the dial finally, cuts the volume to a more modest level as Trinidad James begins his mid-track overtures.

Gets Kevin's attention, looking over, expectant:

> BLACK
> How you get to work?

> KEVIN
> Jitney.
> Bus.
> Sometimes Samantha shoot me out there if I got Lil' Kevin.

Black nodding.

> BLACK
> Can't picture bein' in Miami with no car, man.

> KEVIN
> Yeah, it's real out here.

> BLACK
> I bet.

> KEVIN
> Real slow, real hot, *real* busted, got me like a duck out here.

Both laughing at that, you can be called a lot of things in Miami and next to snitch, duck is about the worst.

> BLACK
> You on one.

 KEVIN
 Nah, man, I'm just tired.
 (and)
 I used to be up in them traps, too. Wasn't easy; was
 hard as hell, harder than this, man, but not much.
 Feel like I work damn near as hard to make a day's
 pay trappin' in two weeks cookin'.

Black just nodding, his blinker flicked, the business of driving.

 KEVIN
 Make everything hurt a lot more. Feel like that cat
 from *In Living Color:* "My neck, my back... my *neck*
 and *my back.*"

That cracking both of them up, nostalgia of it as much as anything else.

The laughter carries them a ways. Before they know it, Black is shifting onto the freeway.

Kevin looking out the window there. On his right as they travel east away from the Miami that brings black boys up so hard: Fisher Island, the Miami immortalized in Rick Ross rhymes and *Miami Vice.*

 KEVIN
 Bet on this the ride, Chi'.

 BLACK
 Can't have you on no Jitney.

More road, more lights, more of the silence mapping out this space between them.

 KEVIN
 So Chiron...

Kevin looking directly at Black now. They're on the freeway; Black is driving. And yet... Kevin holding this thought aloft, looking across the interior of this car until Black looks back, meets his gaze.

He does.

> KEVIN
> You just drove here?

> BLACK
> Yeah.

> KEVIN
> Like you just was *on one* and got on the highway?

> BLACK
> Yeah.

A beat as they hold eyes.

> KEVIN
> Where you gon' stay tonight?

Nothing from Black. *Nothing,* no words, no gestures, nothing rendered from him in this moment.

Black *should* be driving, should have eyes on the road, paying attention to the other cars, the things passed. Instead, all eyes on Kevin, staring back at the man lost in that question, the space between its posing and this beat the clear answer. Kevin looks away, out the window again. The earth just moved. They both felt it.

Kevin reaching for the dial, raises the volume on that sound system. A moment of this travel, "Purple Haze" enveloping them in this unspoken pact for a beat, then...

EXT. MIAMI BEACH PARKING LOT - NIGHT

A public parking lot, open-air, twenty-four hours. Black and Kevin exiting the car, Kevin careful not to slam the door, immaculate this car.

He begins across the lot but looks back — Black is still there, beside the car with the door aloft.

The ocean is out there, the SOUND of it just beyond — wind and rolling waves — a pathway sloping down to shore.

In this darkness, he can't see it from here, but... in Black's gaze? He certainly *can feel it.*

The longest beat, then...

<div style="text-align: right;">UP CUT TO:</div>

EXT. KEVIN'S APARTMENT - NIGHT - ESTABLISHING

Black and Kevin enter the courtyard of this modest complex, make their way across a gravel walk. The SOUND of window-mounted AC units.

The SOUND of privacy.

INT. KEVIN'S APARTMENT - NIGHT

Black standing in the living room as Kevin moves away, disappears into another area of the apartment.

Alone, Black takes the place in: simple, modest, sparsely furnished with things that seem to have been found on sidewalks.

On a table there, a single image of a small boy, a photo that looks very much like the Young Kevin from earlier.

The sound of a toilet flushing, Kevin reappearing now, his work clothes shed, jeans and a T-shirt as he moves through the space.

> KEVIN
> Want somethin' to drink? Beer? Water?

> BLACK
> Yeah. Some water.

Kevin over at the sink now, a straight sight-line to it from the living room here. Black watching as Kevin pours a glass from the tap, adds ice cubes from a plastic tray in the freezer.

Kevin gesturing to a simple folding table near Black, moves over to it and sets down two glasses of water, Black sitting opposite him.

Kevin watching as Black drinks his water, something not quite exaggerated but extended in the act, Kevin's eyes searching the nape of Black's neck.

He smiles.

> KEVIN
> Who is you, man?

> BLACK
> *Who, me?*

> KEVIN
> Yeah, nigga.
> You.
> Them *fronts?* That *car?* Who is you, Chiron?

Black shrugging his shoulders, smiles sheepishly:

> BLACK
> I'm me, man, ain't tryna be nothin' else.

> KEVIN
> So you hard now?

> BLACK
> I ain't say that.

> KEVIN
> Then what?

Beat.

> KEVIN
> Look, I'm not tryna hem you up. Just... I ain't seen you in a minute. Not what I expected, none of it. Not good or bad, just not what I expected.

> BLACK
> Well what did you expect?

Kevin thinking about that one, has to ask himself: what *did* he expect?

> KEVIN
> You remember the last time I saw you?

At first, just a nod from Black, a plaintive gesture from his body but in those eyes, so much more.

> BLACK
> For a long time, tried not to remember.

Kevin nodding.

BLACK
Tried to forget all those times.
The good...
...the bad.
All of it.

KEVIN
Yeah.
I know.

BLACK
When we got to Atlanta... I started over. Built myself from the ground up. Built myself *hard*.

Beat.

BLACK
What about you?

KEVIN
Me? I just kept on, man. I wasn't never worth shit, never did anything I actually wanted to do, was all I could do to do what other folks *thought* I should do, I wasn't never myself.

BLACK
And now?

KEVIN
Now? Now I got Lil' Kev', got this job, man, got another eighteen months of probation.

BLACK
Damn... that's real shit.

 KEVIN
 Yeah, but it's a *life,* you know? I never had that before. Like... I'm tired as hell right now and I ain't makin' more than shoe money, but I got no worries, man. Not them kind what I had before. That's some real shit, that's that Bob Marley shit, nigga.

Black lightening at that, a little smile. It's only amplified as Kevin starts to do a little bob and weave, ad-libbing a Marley-esque hymn.

Black smiling as Kevin's eyes alight with this little ditty. Kevin rises, heads over to the small kitchen — running water.

He toggles a small radio. The SOUND of Kevin rotating through the dial, finally landing on a station, late-night R&B, like DeBarge's *All This Love.*

Kevin comes back over, settles. Muted music from that kitchen radio. He takes up his glass of water and enjoys another sip.

Black fixes him in his sights, more directly than before:

 BLACK
 You're the only man who's ever touched me.

The air going out of Kevin's chest, his gaze fixated on Black's lips, anticipating the words falling from there:

 BLACK
 The only one.

Black's hand is flat atop the table between them. His eyes lower to it:

 BLACK
 I haven't really touched anyone, since.

INT. KEVIN'S APARTMENT, BEDROOM - NIGHT

Black sitting at the foot of the bed, fully clothed, hands clasped between his knees, leaned over slightly.

Kevin standing before him, frozen.

They hold each other's eyes an interminable beat.

Black stands shakily. Kevin watches him as he closes the space between them, drawing right up to him. Kevin takes a hand and lays it flat against Black's chest.

A puzzled look coming over Kevin's face.

 KEVIN
 You shakin'.

 BLACK
 Yeah.

 KEVIN
 Wait.

Kevin crosses the doorway, flips a switch:

TOTAL DARKNESS

...only the soft thudding of feet crossing the floor.

Another beat, then, under darkness:

 BLACK
 I'm shakin'.

 KEVIN
 Yeah.

 BLACK
 I'm still shakin'.

 KEVIN
 Yeah.

The SOUND of bodies touching, the beginning of things, then...
...another sound rising — from afar — the SOUND of waves crashing, rushing onto shore.

And mingling with that rush of waves, the sound of lips and hands, the joining of bodies, somewhere in this darkness Black and Kevin re-learning one another as we CUT TO...

EXT. OCEAN - NIGHT

Those waves heard crashing moments earlier on full display, rushing ashore at a frothy run.

Dark out, extremely dark save for the lights of beach bars a ways down the ocean front. The undulating rhythms of the Atlantic catch the moon, glint it all over.

As we observe this movement of water and dance of light, shoulders appear, bare, gaunt: LITTLE from our opening episode.

Calmly, methodically, Little moves across the sand, approaching the water. A beat more of Little easing up to the surf, then...

...he looks back: his dark skin moistened in the ocean spray, moon catching him same as it's catching the surface of the Atlantic.

And those eyes: looking right at us, staring plaintively, plainly, nothing requested, no expectation: just a clear, undisturbed openness.

Hold this gaze, then...

```
MOONLIGHT
```

...Little turning from us, his form and movement slowly, steadily melding into the flow of light and waves as he heads out into the ocean and we...

FADE TO BLACK.

MOONLIGHT

Section II.

24 Frames

Cinematography by James Laxton

01. 00:00:38
02. 00:02:33
03. 00:11:39
04. 00:15:28
05. 00:18:28
06. 00:30:13
07. 00:30:20
08. 00:34:27
09. 00:43:48
10. 00:43:49
11. 00:55:11
12. 00:56:50
13. 01:03:56
14. 01:06:58
15. 01:15:39
16. 01:20:35
17. 01:21:50
18. 01:24:37
19. 01:24:41
20. 01:36:25
21. 01:45:29
22. 01:45:34
23. 01:45:44
24. 01:46:25

MOONLIGHT

00:00:38

152

00:02:33

154

00:11:39

00:15:28

00:18:28

160

00:30:13

00:30:20

164

00:34:27

00:43:48

00:55:11

00:56:50

01:03:56

01:06:58

01:15:39

181

01:20:35

182

01:21:50

184

185

01:24:37

01:24:41

01:36:25

01:45:29

01:45:44

01:46:25

Section III.

Film Noir

by Hilton Als

Hilton Als won the 2017 Pulitzer Prize for criticism. He is a staff writer and theater critic at The New Yorker *and an associate professor of writing at Columbia University.*

Did I ever imagine, during my anxious, closeted childhood, that I'd live long enough to see a movie like *Moonlight*, Barry Jenkins's brilliant, achingly alive new work about black queerness? Did any gay man who came of age, as I did, in the era of Ronald Reagan, Margaret Thatcher, and AIDS, think he'd survive to see a version of his life told onscreen with such knowledge, unpredictability, and grace? Based on a story by the gay black playwright Tarell Alvin McCraney — Jenkins himself is not gay — the film is virtuosic in part because of Jenkins's eye and in part because of the tale it tells, which begins in 1980s Miami.

Four white Miami-Dade police officers have beaten a young black man to death and been acquitted of manslaughter, setting off riots in the city's black enclaves — Liberty City, Overtown, and elsewhere. It's hard for a man of color walking those sun-bleached streets not to watch his back or feel that his days are numbered. That's how Juan (the beautiful Mahershala Ali) carries himself

— defensively, warily. He's a dope dealer, so there's that, too. He may be a boss on the streets — his black do-rag is his crown — but he's intelligent enough to know that he's expendable, that real power doesn't belong to men like him. Crack is spreading through the city like a fever. Stepping out of his car, Juan asks a cranky drug runner what's up. (Jenkins and his ardent cinematographer, James Laxton, film the car as if it were a kind of enclosed throne.) Juan, his mouth fixed in a pout — sometimes he sucks on his tongue, as if it were a pacifier — doesn't take his eyes off the street. He can't afford to; this situation, any situation, could be changed in an instant by a gun or a knife.

In this world, which is framed by the violence to come — because it will come — Juan sees a skinny kid running, his backpack flapping behind him. He's being pursued by a group of boys, and he ducks into a condemned building to escape. Juan follows, entering through a blasted-out window, a symbol, perhaps, of the ruin left by the riots. Inside, in a dark, silent space, the kid stares at Juan, and Juan stares at the kid. There's a kind of mirroring going on. Maybe Juan is looking at his past while the boy looks up at a future he didn't know he could have. It's a disorienting scene, not so much because of what happens as because of what doesn't happen. Throughout the movie, Jenkins avoids what I call Negro hyperbole — the overblown clichés that are so often used to represent black American life. For instance, Juan doesn't take that runaway kid under his wing in order to pimp him out and turn him into a drug runner; instead, he brings him home to feed him, nourish him.

Juan lives in a small, unassuming house with his soft-spoken but confident partner, Teresa (played by the singer Janelle Monáe). The couple look on as the kid eats and eats; it's clear, though, that he's hungry for more than

food. The boy doesn't even say his name, Chiron, until Juan nudges him: "You don't talk much but you damn sure can eat." The affectionate scolding makes Chiron (Alex Hibbert, a first-time actor, who couldn't be better) sit up and take notice; it tells him that he counts. And he knows he counts even more when Juan calls him by his nickname — Little — as a way of claiming him.

"Faggot" is another name, and it's one that Chiron hears often as he grows up. He's an outsider at school, and at home, too. He lives in public housing with his single mother, Paula (Naomie Harris), who goes on drug binges, less to alleviate her sadness than to express her wrath — against the world and, especially, against her son, who she thinks keeps her from the world. Chiron lives for the moments when he can get away from his mother's countless recriminations and needs, and swim in the unfamiliar waters of love with Juan and Teresa. One indelible scene shows Juan holding Chiron in his arms in a rippling blue ocean, teaching him to float — which is another way of teaching him the letting go that comes with trust, with love.

But, at the end of every outing, Teresa and Juan show their respect by returning Chiron home. No matter how awful Paula is, she is still Chiron's mother. This gesture is one of many that Jenkins, who, like McCraney, was raised in Liberty City, understands from the inside out. Growing up in this community, Juan and Paula were taught to care for children, their own and others'. (There are no white characters in the film, and this is a radical move on Jenkins's part. Whites would have introduced a different dynamic to *Moonlight*. Jenkins's story is about a self-governing black society, no matter how fractured.) But drugs have made a mess of family, or the idea of family, and Paula gets in Juan's face when he tries to stop her from using. She has a child, sure, but how can he

talk when he's the one selling drugs? It's a vicious cycle, in which the characters are oppressed by everything but hope. Still, Juan does hope, if only for Chiron. That he is able to pluck that feeling out of the darkness of those Miami nights makes him a classically heroic figure: he knows his limitations, he knows that life is tragic, but he is still willing to dream.

About thirty minutes into the film, Chiron, sitting at Juan and Teresa's orderly table, asks what a faggot is. At the screening I attended, the entire audience froze, as did the figures onscreen. Then Chiron asks if he himself is a faggot. There's no music in this scene; no one cries; Juan doesn't grab a gun and try to blow the slandering universe away. Instead, he takes the word apart, and doesn't take Chiron apart with it. He knows that Chiron is marked for misery, and how will Juan's heart bear it, let alone Chiron's?

Moonlight undoes our expectations as viewers, and as human beings, too. As we watch, another movie plays in our minds, real-life footage of the many forms of damage done to black men, which can sometimes lead them to turn that hateful madness on their own kind, passing on the poison that was their inheritance. As Juan squires his fatherless friend about, we can't help thinking, Will he abuse him? Will it happen now? Jenkins keeps the fear but not the melodrama in his film. He builds his scenes slowly, without trite dialogue or explosions. He respects our intelligence enough to let us just sit still and watch the glorious faces of his characters as they move through time. Scene follows scene with the kind of purposefulness you find in fairy tales, or in those Dickens novels about boys made and unmade by fate.

Jenkins has influences — I would guess that Apichatpong Weerasethakul, Terrence Malick, and Charles Burnett are

high on the list, along with Michael Roemer's 1964 film *Nothing But a Man*, one of the first modern black love stories to avoid buffoonery and improbability — but what really gets him going here is filmmaking itself, and the story he's telling. Directors such as Marlon Riggs and Isaac Julien explored gay black masculinity in the '90s, but they did so in essay-films, which allowed the audience a kind of built-in distance. Of course, no one in the '90s wanted to finance films about gay black men. Twenty years later, I still don't know how Jenkins got this flick made. But he did. And it changes everything.

The film is divided into three parts, titled "Little," "Chiron," and "Black." In the second part, Chiron (played now by Ashton Sanders) is a teenager, thin and walking with the push, resolve, and loneliness of a character for whom Billie Holiday would have given her all in a song. Like any young person, Chiron wants to be claimed bodily but is not entirely in his body. He's growing up without much reinforcement outside Juan and Teresa's home. Paula's drug addiction has escalated and so has her anger. She's a rotten baby, flailing around, as full of bile as Terrel (Patrick DeCile, in an incredible characterization), who bullies Chiron at school. So when a classmate, Kevin (Jharrel Jerome), shows Chiron something other than hostility, it feels like a kind of fantasy. Indeed, after Kevin jokes with Chiron about a girl, he dreams about Kevin having sex with her. And it's like a dream one night when Chiron, trusting little but wanting to trust more, approaches Kevin at the beach where Juan taught him to swim.

The light-skinned Kevin has nicknamed Chiron Black, and he asks why, wondering if it's a put-down. Kevin, who is more comfortable in his own body, says that it's because Chiron is black; to him, it's not an insult. This moment of confusion — about internalized self-hatred

and the affection of naming — is unlike anything that's been put onscreen before; it shows what freedom and pain can look like, all in one frame. When the boys kiss, Chiron apologizes for it, and we wince, because who among us hasn't wanted to apologize for his presence? Intimacy makes the world, the body, feel strange. How does it make a boy who's been rejected because of his skin color, his sexual interests, and his sensitivity feel? Kevin says, "What have you got to be sorry for?" As he works his hand down Chiron's shorts, the camera pulls back; this is the only moment of physical intimacy in the film, and Jenkins knows that in this study of black male closeness the point isn't to show fucking; it's to show the stops and starts, the hesitation, and the rush that comes when one black male body finds pleasure and something like liberation in another.

Watching Sanders play Chiron at this stage of his life is rather like seeing Montgomery Clift act for the first time, or Gloria Foster in *Nothing But a Man*. There's no accounting for talent like this. Sanders has a conjurer's gifts, and an intuitive understanding of how the camera works — how it can push into an actor's face and consciousness, and how the actor can push back against the intrusion by inhabiting the reality of the moment.

But the moment of love doesn't last. When Terrel challenges Kevin about his attachment to Chiron, Kevin beats Chiron up, and then Terrel jumps on him, too. It's *The Lord of the Flies* all over again: whale on sensitivity before it can get to you. In a bid to protect his dream of love, Chiron shows up at school one day and, wordlessly, breaks a chair over Terrel's back. It's every queer kid's revenge fantasy, but what follows is every queer kid's reality: fight back, and you'll pay for it; the power does not belong to you.

In the third part of the film, Chiron (gorgeously played by Trevante Rhodes) is an adult, but still looking after his mother. She's in rehab in Atlanta, and he has fulfilled his destiny by example: like Juan, he's a drug dealer in a do-rag. But he doesn't have a Teresa, doesn't have anyone. He wears his sensitivity like a shroud around his now muscular body, which looks very black in the moonlight as he lies in bed, startled to have received a phone call from Kevin after many years. Rhodes's portrayal of the grownup Chiron feels like a natural evolution from the earlier performances. The gold fronts that his Chiron wears are just another form of armor against longing, in a mouth that yearns to taste Kevin's once again, to relive that forbidden love, for which black men sometimes punish one another. Rarely has the world taught them not to. But at times, when no one's looking, love happens, just the same.

This essay originally appeared in the October 24, 2016 print issue of The New Yorker

Section IV.

Acceptance Speeches

The 89th Academy Awards

Moonlight made history at the 2017 Academy Awards, and not only because of the dramatic way it was awarded Best Picture. Mahershala Ali became the first Muslim actor to win an Oscar in the ceremony's eighty-nine-year history. And *Moonlight,* taking the night's top prize, became the first film centered on an LGBTQ character to win Best Picture, the first film featuring an all-black cast to win Best Picture, and the lowest-budget Best Picture winner ever.

Amid the frenzy following the Best Picture mix-up, Barry Jenkins didn't get to deliver the acceptance speech he had prepared. Here is that speech.

Best Picture

Tarell and I are Chiron. We are that boy. And when you watch *Moonlight*, you don't assume a boy who grew up how and where we did would grow up and make a piece of art that wins an Academy Award. I've said that a lot, and what I've had to admit is that I placed those limitations on myself, I denied myself that dream. Not you, not anyone else — me. And so, to anyone watching this who sees themselves in us, let this be a symbol, a reflection that leads you to love yourself. Because doing so may be the difference between dreaming at all and, somehow through the Academy's grace, realizing dreams you never allowed yourself to have. Much love.

Barry Jenkins

Best Supporting Actor

Wow. I want to thank my teachers, my professors. I had so many wonderful teachers. And one thing that they consistently told me is — Oliver Chandler, Ron Van Lieu, Ken Washington — is that it wasn't about you. It's not about you. It's about these characters. You're in service to these stories and these characters. I'm so blessed to have had an opportunity. It was about Juan. It was about Chiron. It was about Paula.

Cast and crew. It was just such a wonderful experience. Thank you, Barry Jenkins. Thank you to Tarell Alvin McCraney. Adele Romanski, who forced Barry to cast me. It's just such a wonderful experience, and I have so many people to thank who've got me here.

My manager: thank you so much. And to the rest of the cast who did wonderful work — any one of them could be up here right now holding this trophy. It's such a gift getting to work with you and to be inspired by you and the performances that you all offered up. Thank you, the Academy, I really appreciate this.

And lastly, I just want to thank my wife, who was in her third trimester doing awards season. We just had a daughter four days ago. I just wanna thank her for being such a soldier through this process... and really carrying me through it all. Thank you, I really appreciate it. Peace and blessings.

Mahershala Ali

Best Adapted Screenplay

Thank you to the Academy. Thank you, A24. Thank you, Plan B. Thank you to our amazing cast. Thank you, my mom, my sister, everybody in Miami. I want to thank my reps, three amigos, Jay Baker at CAA, Joel Ross and Jamie Feldman. And two women in particular. My publicist, Paula Woods, and Heather Seacrist at A24. Thank you for taking care of me. I told my students, be in love with the process, not the result. I really wanted this result. All you people who feel like there's no mirror for you, the academy has your back, the ACLU has your back, we have your back, and for the next four years, we will not forget you.

Barry Jenkins

Amen, brother. I just want to echo everything he just said, but I want to say thank God for my mother, who proved to me through her struggles and the struggles that Naomie Harris portrayed for you, that we can be somebody. Two boys from Liberty City up here representing 305. This goes out to all those black and brown boys and girls and non-gender-conforming who don't see themselves, we're trying to show you *you*, and us. Thank you, thank you. This is for you.

Tarell McCraney

"MOONLIGHT"

DIRECTED BY
Barry Jenkins

SCREENPLAY BY
Barry Jenkins

STORY BY
Tarell Alvin McCraney

PRODUCED BY
Adele Romanski p.g.a.

EXECUTIVE PRODUCER
Brad Pitt
Sarah Esberg

CO-PRODUCER
Andrew Hevia

ASSOCIATE PRODUCER
John Montague

EDITED BY
Nat Sanders
Joi McMillan

MUSIC SUPERVISOR
Maggie Phillips

COSTUME DESIGNER
Caroline Eselin-Schaefer

An A24 and Plan B
Entertainment Presentation

PRODUCED BY
Dede Gardner p.g.a.
Jeremy Kleiner p.g.a.

EXECUTIVE PRODUCER
Tarell Alvin McCraney

CO-PRODUCER
Veronica Nickel

CINEMATOGRAPHY BY
James Laxton

MUSIC BY
Nicholas Britell

PRODUCTION DESIGNER
Hannah Beachler

CASTING BY
Yesi Ramirez, CSA

A Plan B Entertainment
and
Pastel Production

CAST (IN ORDER OF APPEARANCE)

```
Juan.................................................MAHERSHALA ALI
Terrence...............................................SHARIFF EARP
Azu..........................................DUAN "SANDY" SANDERSON
Little.................................................ALEX HIBBERT
Teresa................................................JANELLE MONÁE
Paula..................................................NAOMIE HARRIS
Kevin (9).................................................JADEN PINER
Longshoreman.................................HERMAN 'CAHEEJ' MCGLOUN
Portable Boy 1......................................KAMAL ANI-BELLOW
Portable Boy 2...........................................KEOMI GIVENS
Portable Boy 3........................................EDDIE BLANCHARD
Gee.......................................................RUDI GOBLIN
Chiron................................................ASHTON SANDERS
Mr. Pierce..................................................EDSON JEAN
Terrel................................................PATRICK DECILE
Samantha...........................................HERVELINE MONCION
Kevin (16).........................................JHARRELL JEROME
Pizzo..............................................FRANSLEY HYPPOLITE
Old School Guard.....................................JESUS MITCHELL
```

Antwon	LARRY ANDERSON
Principal Williams	TANISHA CIDEL
Black	TREVANTE RHODES
Travis	STEPHON BRON
Kevin	ANDRÉ HOLLAND
Tip	DON SEWARD
Terrel Stunt Double	MARC JOSEPH

CREW

Line Producer	VERONICA NICKEL
Unit Production Manager	JENNIFER RADZIKOWSKI
Additional Line Producer	ELANE SCHMIDT SCHNEIDERMAN
Production Coordinator	PEDRO GUILLEN
Production Supervisor	STEVE DEL PRETE
Assistant Production Supervisor	ROGER MENDOZA
Associate Production Supervisor	REYNALDO RODRIGUEZ
Script Supervisor	MELINDA TAKSEN
Additional Script Supervisor	LAURA PINTO
First Assistant Camera	STEPHANE RENARD
Second Assistant Camera	WILLIAM WELLS
Additional Second AC	JONATHAN PROENZA
Digital Imaging Technician	JOE DARE
Additional DIT	CHRISTOPHER GARCIA
Steadicam Operator	JAMES BALDANZA
	OSVALDO SILVERA
Still Photographer	DAVID BORNFRIEND
Gaffer	KIVA KNIGHT
Rigging Gaffer	ARNOLD 'RUSTY' POUCH
Best Boy Electricians	WILLIAM 'GENIE' CINTRON
Additional Best Boy Electric	ANDY FUTO
Company Electricians	OLIVER ALVAREZ
	CHRISTOPHER BELCARRIES
	BEN CLERVEAUX
	LUIS COSTE
	JOSE FUENTES
	TAYLOR JONES
	ELIO JORBAN
	DAVID OLSEN
	ADAM ROBACK
	DANIEL WILLIAMS
	JEAN DAGUILLARD
	PAUL OLSEN
	DANIEL REYES
Key Grip	ANTHONY SCHRADER
Additional Key Grip	DAVID LANES
Best Boy Grip	JOHN GALINDEZ
Company Grips	JOSE BRANAS
	JEAN E. DAGUILLARD III
	DANIEL REYES
	GIOVANNI RODRIGUEZ
	FABRICIO SACKNIES
	JOHN SIDER JR
	ANDY FUTO
	ADAM ROBACK
Production Sound Mixer	CHRISTOPHER GILES
Boom Operator	JULIO ALVAREZ
Art Decorator	MABEL BARBA
Set Decorator	REGINA MCLARNEY CROWLEY
Lead Man	JEREMY KOENIG
Additional Lead Men	ROBERT P. CROWLEY

...	RYAN CROWLEY
Property Master...................................	BECCA KENYON
Assistant Prop Masters.........................	CLARK GRIMES
...	YVONNE AJA
Art Department Intern..........................	KEITER LIRIANO
Head Make-Up.....................................	DONIELLA DAVY
Head Hair...	GIANNA SPARACINO
Wardrobe Supervisor...........................	FERNANDO RODRIGUEZ
Costumers...	WAÏNA CHANCY
...	LISA JAMOUZIAN
Interns (Office)....................................	LAUREL SCHMIDT
...	NICOLE MALDONADO
Interns (Production).............................	REED HAMPLE
...	AL MICHEL
Production Accountant.........................	HOLLY POPOWSKI
Set Medics..	GEORGE SCHOENDORFER
...	JUAN F. DANGER
...	CODY FIGUEREDO
...	ALEXANDER EDLIN
Water Safety/Set Medic........................	PATRICK 'JACK' SELTS
Stunt Coordinator................................	ALEXANDER EDLIN
...	ARTIE MALESCI
Location Manager................................	FAREN HUMES
Location Scout....................................	KEISHA RAE WITHERSPOON
Location Scout....................................	ROD DEAL
Location PA..	ZOILA J. MILLIEN
...	DANIEL CAPESTANY
Location Intern....................................	STEPHANIE WEETMAN
Key Set PA...	DUANE KIDD
Production Assistants...........................	ALLEN GROOVER
...	ANDRE ADAMS
...	BRYAN ANGARITA
...	CAROLINA ROMERO
...	DANNY GAURINO
...	DANNY GONZALEZ
...	DANNY RODRIGUEZ
...	JASON WOOL
...	MATTHEW ROMANSKI
...	ROBERT COLOM
...	SHELBY HALBERG
Assistant to Mr. Jenkins.......................	DANNY RODRIGUEZ
Assistant to Mr. Kleiner.......................	CAROLINE CARRNS
On Set Teacher...................................	DEBY STEWART
Craft Service......................................	LINDA PILGRIM
Additional Craft Service.......................	DAWN MCLEAOD
Catering by..	HEALTHY MEALS BY ALYSE
...	ALISA MCGOWAN
BG Casting...	MONICA SORELLE
BG Casting Assistant...........................	MADELEINE ESCARNE
Picture Cars Provided by.....................	QUICKSEND SERVICES LLC
...	CHRIS HANLON
...	ALLEN JOSEPH
...	MONGUL
...	KAR CONNECTION INC
...	COPSHOPMIAMI.COM
...	TRAY HENDERSON
Dailies...	EPS-CINEWORKS
Color Services Provided by..................	COLOR COLLECTIVE
Colorist..	ALEX BICKEL
Color Assistant...................................	DANIEL ORENTLICHER
Color Producer...................................	CLAUDIA GUEVARA
Sound Post Production........................	WILDFIRE SONIC MAGIC
Re-Recording Mixer.............................	CHRIS DAVID

Supervising Sound Editor	JOSHUA ADENIJI
Sound Effects Editors	CHRISTOPHER BONIS
ADR/Dialogue Editor	RYAN BRILEY
ADR Mixer	TRAVIS MACKAY
Foley Artist	VICKI O'REILLY VANDEGRIFT
ADR Facility Coordinator	BRITTANY MALOOLY
Sound Studio Manager	ROBERT DEHN
Additional Re-Recording Mixer	ONNALEE BLANK, CAS
Additional Re-Recording Mixer	MATHEW WATERS, CAS
Additional Re-Recording Mixer	BENJAMIN COOK, MPSE
Additional Re-Recording Mixer	SHAUGHNESSY HARE
Visual Effects provided by	SIGNIFICANT OTHERS
President	STEPHANIE APT
Executive Producer	SARAH ROEBUCK
Head of Production	JEN SIENKWICZ
VFX Producer	ALEK ROST
VFX Artist	DIRK GREENE
VFX Artist	BETTY CAMERON
Title Design	Sebastian Pardo, MEMORY
Score Produced and Orchestrated by	NICHOLAS BRITELL
Score Recorded and Mixed by	TOMMY VICARI
Music Consultant	JOHN FINKLEA
Violin Soloist	TIM FAIN
Pianist	NICHOLAS BRITELL
Music Preparation	TONY FINNO
Score Mixed at	AVATAR STUDIOS NYC
	AND DOWNTOWN MUSIC STUDIOS NYC
Music Coordinator	CHRISTINE ROE
Music Consultant	SETH FRIEDMAN
Deliverables by	TECHNICOLOR POSTWORKS NEW YORK
Finishing Producer	ANDREW MCKAY
Account Executive	BARBARA JEAN KEARNEY
Arri Alexa Provided by	CINEVERSE
Grip + Lighting provided by	MAGIC II GRIP AND LIGHTING
Walkies provided by	TRADE AUDIO
Process Trailer Rental	UNIQUE PRODUCTIONS
Production Services Provided by	UPLOAD FILMS: TODD WILLIAMS
	NICK THURLOW
	JOHN PORTNOY
Rental Production Office	YOUNG ARTS FOUNDATION
Production Counsel	GRAY KRAUSS STRATFORD SANDLER
	DES ROCHERS LLP
	ANDRÉ DES ROCHERS, ESQ.
	KRISTINA CHIU, ESQ.
Production Insurance Provided by	MOMENTOUS INSURANCE
	BROKERAGE, INC.

MUSIC

EVERY NIGGER IS A STAR	M FROM VESPERAE SOLENNES
Written by Boris Gardiner &	DE CONFESSORE, K. 339
Barrington Gardiner	Written by
Performed by Boris Gardiner	Wolfgang Amadeus Mozart
Remix by Dennis "DEZO" Williams	Conducted by Nicholas Britell
Courtesy of Now-Again Records, LLC	Courtesy of Lake
obo Jazzman Records Ltd	George Entertainment LLC

MINI SKIRT
Written by Sam Knott
Performed by The Performers
Courtesy of The Numero Group
By Arrangement with
Bank Robber Music

TYRONE
Written by Erica Wright
and Norman Hurt
Performed by Erykah Badu
Courtesy of Motown Records under
license from Universal
Music Enterprises

TUMBLING DOWN
Written by Langston George
and Charles French
Performed by Langston & French
Courtesy of The Numero Group By
arrangement with Bank Robber Music

IT'LL ALL BE OVER
Written by Leonard Sanders
Performed by Supreme Jubilees
Courtesy of Light In The
Attic Records

ONE STEP AHEAD
Written by Charles Singleton
and Eddie Snyder
Performed by Aretha Franklin
Courtesy of Columbia Records
By Arrangement with Sony
Music Licensing

CELL THERAPY
Written by Robert Barnett,
Willie Knighton, Cameron Gipp,
Raymon Murray, Patrick Brown,
Rico Wade, Thomas Callaway
Performed by Goodie Mob
Courtesy of RCA Records
By Arrangement with Sony
Music Licensing

PLAY THAT FUNK (FEAT. TRAVIE BOWE)
Written by Hemsley F.
Turenne Jr. and Travis Bowe
Performed by Prez P and Travis Bowe
Courtesy of Pandemonium / Da Campsite

CUCURRUCUCÚ PALOMA
Written by Tomás Méndez Sosa
Performed by Caetano Veloso
Courtesy of Universal International
Music, B.V. under license from
Universal Music Enterprises

CLASSIC MAN
Written by Charlotte Emma
Aitchison, George Astasio,
Nathaniel Irvin III,
Roman GianArthur Irvin,
Amethyst Amelia Kelly,
Kurtis Isaac McKenzie,
Jidenna T. Mobisson,
Jason Pebworth, Jasbir Singh Sehra,
Jonathan Christopher Shave,
Eleanor Kateri Tannis,
Nana Kwabena Tuffuor,
John Turner, Milan Wiley
Performed by Jidenna feat.
Roman GianArthur
Courtesy of Wondaland/Epic Records
By Arrangement with Sony
Music Licensing

OUR LOVE
Written by Cornelius Cade
Performed by The Edge of Daybreak
Courtesy of The Numero Group By
Arrangement with Bank Robber Music

HELLO STRANGER
Written by Barbara Lewis
Performed by Barbara Lewis
WARNER-TAMERLANE PUBLISHING CORP. (BMI)
Courtesy of Atlantic Recording Corp.
By Arrangement with Warner Music Group
Film & TV Licensing

THE DIRECTOR WISHES TO THANK
6G
Aaron Katz
African Heritage Cultural Arts Center
Alcene and Ken
Alicia Wilson
Amy Seimetz
André Des Rochers
Anna Boden
Annette Savitch
Annie Schmidt

Ashley Crowe
Becca Cosmetics
Bill Burgess
Borscht Corp
Brandt Joel
Brent Morley
Brian Clark
Broward County Public School
Bryan Lourd
Caitlin Sullivan
Camry
Carl Juste
Carla Hill
Carolyn Govers
Charles Drew Elementary
Christoph Baaden
Cinereach
City of Miami
City of Miami Beach
City of Miami Police
Clyde Ferrell
Corrine Hayoun
Cynthia Pett
Danielle Shebby
Dante
Daphney Dalla
Dave Wirtschafter
David Goodman
Detective Kevin Ruggiero
Doña Silvina Malbec
Donna Wellington
Edson Jean
Erene Romanski
Eric Brooks
Esther Chang
Esther Park
Gary Rosenberg
Geoff Quan
Gerald Saintil
Goldcrest Post, London
Graham Leggat
Graham Winick
Gwen Cherry Park
Harbor Picture Company, New York
Harold Ford
Jamal Law
James "Munch" Mungin II
Jamie Feldman
Jason Fitzroy Jeffers
Jason Weinberg
Jay Baker
Jay Van Hoy
Jesus Mitchell
Jewerl Ross
Jimmy Darmody
Jimmy's Eastside
John Lyons
John Stern
Jon Cassir
Jon Liebman
Jonathan David Kane
Juan Camilo Barriga
Julia Shirar

Justin Simien
Keisha Witherspoon
Keith Wade
Kelly Parker
Kerris Miller
Kahlil Joseph
Lagniappe, Miami
Lekir "Lyric" Calhoun
Leslie Shatz
Lisa Leone
Lord Byron, Brussels
Lucas Leyva
Margaret Howell
Minerva Hall
Magic 2, Miami
Margot Moss and Kevin Hellmann
Maris Curran
Maria Formoso
Marco Antonio Martinez
Marissa Stone
Mark Ceryak
Mark Harrington
Marshall Davis
Martin Romanski
Megan Crawford
Miami Children's Initiative
Miami Dade County
Miami Grand Beach Hotel
Micah Green
Mikael Moore
Mitch Kaplan
Mongul
Morgan Kellum & Cineverse
Ms. Romania
Ms. Sarah for keeping it 'chill'
Ms. Tanisha Cidel
Naima Ramos-Chapman
Nakiesha
Natalie Difford
Norland Middle Drama Program
Ojay Miller
Onye Anyanwu
Outpost Audio, Miami
Ozzie Oswaldo
Panther Coffee
Paul & Annette Smith
Perri Kipperman
Queen Aggie & Chick
Radha Blank
Red Studios
Riel Roch-Decter
Rodrigo Gonzalez
Rudi Goblen
Ryan Coogler
Ryland Walker Knight
Significant Others
Shane Carruth
Shelly Sroloff
Stella and Banana
Tacolcy Center
Talitha Watkins
Tahir Jetter
Teddy Harrell

Terrance Nance
The Corner, Miami
The Eshietedoho Clan
The Hevia Family
The National YoungArts Foundation
The Piner Family
The Poke N'Beans
The Tacolcy Red Raiders
The Vagabond, Miami
Third Horizon Media
Two Sisters, SF
United States Artists Org
VCA Hollywood Animal Hospital
Wondaland

SPECIAL THANKS TO SAG-AFTRA

FILMED ON LOCATION IN MIAMI FLORIDA

ARRI

SAG CORPORATION

IATSE

COLOR COLLECTIVE

J.L.FISHER INC.

CINERVERSE

WILDFIRE FILMS

END CRAWL

© 2016 DOS HERMANAS, LLC. ALL RIGHTS RESERVED.

THE EVENTS, CHARACTERS AND FIRMS DEPICTED IN THIS
PHOTOPLAY ARE FICTITIOUS. ANY SIMILARITY TO
ACTUAL PERSONS, LIVING OR DEAD, OR TO ACTUAL EVENTS OR
FIRMS IS PURELY COINCIDENTAL.

OWNERSHIP OF THIS MOTION PICTURE IS PROTECTED UNDER THE
LAWS OF THE UNITED STATES AND ALL OTHER
COUNTRIES THROUGHOUT THE WORLD. ALL RIGHTS RESERVED.
ANY UNAUTHORIZED DUPLICATION, DISTRIBUTION,
OR EXHIBITION OF THIS FILM OR ANY PART THEREOF
(INCLUDING SOUNDTRACK) IS AN INFRINGEMENT OF
THE RELEVANT COPYRIGHT AND WILL SUBJECT THE INFRINGER TO
SEVERE CIVIL AND CRIMINAL PENALTIES.

OWNERSHIP OF THIS MOTION PICTURE IS PROTECTED BY
COPYRIGHT AND OTHER APPLICABLE LAWS, DISTRIBUTION AND ANY
UNAUTHORIZED DUPLICATION, OR EXHIBITION OF
THIS MOTION PICTURE COULD RESULT IN CRIMINAL PROSECUTION
AS WELL AS CIVIL LIABILITY.

Publisher
A24 Films LLC
31 West 27th Street
New York, NY
a24films.com

Film Stills
Courtesy of A24 Films LLC

Creative Direction
Zoe Beyer

Editor
Mark Lotto

Special Thanks
Dave Herr
Lawrence Levi
Rebecca Ribeiro
Danny Rivera

Book Design
Actual Source
50 E 500 N #103
Provo, UT
actualsource.work

Typography
Stempel Garamond
Folio Extended
Monument Grotesk Mono

Tip-In
Sticker Garda Gloss 135g

Paper
Munken Polar Rough 150 GSM
Garda Gloss 150 GSM

Printer
Graphius
Eekhoutdriesstraat 67
9041 Gent, Belgium
graphius.com

Second Edition of 10000

"Film Noir" by Hilton Als. Copyright ©2016 by Hilton Als, first published in *The New Yorker*, used by permission of The Wylie Agency LLC.

©2019 the authors, editors, and owners of all respective content.

All rights reserved; no part of this publication may be reproduced, stored in a retrieval system, or transmitted in any form or by any means, electronic, mechanical, photocopying, recording, or otherwise, without prior written consent of the publisher.

ISBN 978-1-7339920-2-2

A24